PHOTOGRAPHER

Exploring the Hidden
San Francisco Bay Area

R. F. Paulus

AMERICA
THROUGH TIME®
ADDING COLOR TO AMERICAN HISTORY

America Through Time is an imprint of Fonthill Media LLC
www.through-time.com
office@through-time.com

Published by Arcadia Publishing by arrangement with Fonthill Media LLC
For all general information, please contact Arcadia Publishing:
Telephone: 843-853-2070
Fax: 843-853-0044
E-mail: sales@arcadiapublishing.com
For customer service and orders:
Toll-Free 1-888-313-2665

www.arcadiapublishing.com

First published 2021

Copyright © R. F. Paulus 2021

ISBN 978-1-68473-008-7

Typeset in Gotham Book
Printed and bound in England

Contents

Foreword

I came into this game for the action, the excitement. Go anywhere, travel light, get in, get out, wherever there's trouble, a man alone. Now they got the whole country sectioned off, you can't make a move without a form.

Harry Tuttle, *Brazil*

One of mankind's primary drives has always been the desire to explore. This integral human characteristic has informed and inspired most of our discoveries in engineering, psychology, astronomy, chemistry, as well as the geographical expansionism that has been a hallmark of our species ever since we began to walk upright. There are deeply ingrained evolutionary reasons for this. Survival could require leading your tribe over the mountains to a new, unknown place with a better food supply. The desire to plumb the unknown would encourage interacting with other peoples, eventually interbreeding, strengthening the genetic makeup of future generations. Knowledge of new places could serve humanity by informing the sciences over time.

Geographical exploration of our planet, with the exception of the still vastly uncharted ocean floor, has run its course over the centuries, leaving us now at present day with virtually every inch of Earth's landmass explored. Some places have been charted, catalogued, mapped and occupied only to be lost again to the exodus of past generations due to climate change, the incursion of hostile invaders, the promise of better farming or easier hunting elsewhere, perhaps "the new land across the vast plain." Our hunger for discovering the new, the novel, to behold the "Undiscovered Country," is so profound that it can drive us to places even while facing the portent of no return. The loss of this wonder of the unknown, as embodied in the cliche of the places at the edge of old maps with an inscription such as: "here be dragons," will never be total because the places discovered will, over time, be lost again only to be rediscovered.

Urban Exploration, or UrbEx, is primarily the pursuit of access to and knowledge of man-made environments either active, dormant and/or abandoned.

Urban Exploration can be divided into a few overlapping categories:

Draining: The exploration of sewers and storm drains.

Live Infrastructure Sites: Exploring environments and systems that are in use and (usually) maintained by workers, such as bridges, skyscrapers (often under construction) active subway tunnels, power and (other utility) tunnels and plants, active factories, dams & mines.

Disused, Abandoned and Decaying Locations: Crumbling decrepit mansions, schools, housing blocks, vehicle depots, tunnels, skyscrapers and ships, etc.

B.A.S.E. Jumping, Drain Kayaking and other "extreme sports": using the urban environment as a playground.

A genuine urban explorer's love for these places is fierce and true. Knowledge of how cities actually work and what channels the pulsing and dynamic systems that sustain us take in order to transport us to work every day, or to bring us our power, goods, and water while taking away our waste, is a heady knowledge indeed. The average citizen walks or drives past elaborate, intricate and powerful networks of delivery and sustenance every day, never giving these brilliant creations a passing thought, never wondering—or if wondering, never deducing—how these systems came into being, how extensive they might be, nor how they serve mankind.

My introduction to urban exploration was self-directed, when at the age of eleven I tried to convince my friends to join me in entering the dark storm drainage tunnels that carried Cowboy Creek from one end of the college campus to the other, invisible under the small town in which I grew up. I also found a way to climb across the local river on an old road bridge by clambering atop a water pipe and the steel beams that supported it below the elevated road deck. A few years later, shortly after my arrival in San Francisco, I joined The San Francisco Suicide Club, a band of "psychogeographers," pranksters, and street artists. Over the next twenty-five years, urban exploration was a major activity of this group and its successor, The Cacophony Society. The first time I ever heard the term "urban exploration" was from Suicide Club co-founder Gary Warne sometime in 1977. As a nineteen-year-old adventurer, I thought, as all young men must, that I and my fellows invented our field of interest. Surely before us no one had explored tunnels, massive abandoned breweries, climbed bridges or crept beyond the "NO TRESPASSING" signs. As I amassed experience and stories, as I read and studied, I realized that we were not innovators, rather intrepid explorers in a long history of exploration, going back as far as 2nd Dynasty Egyptians exploring the overgrown and desolate temples and pyramids of the 1st Dynasty.

R. F. Paulus is such an intrepid explorer, carrying on in the pursuit of lost vistas and reclaimed landscapes. With his passion and skill at recording these deep environments, each one ensconcing a singular *genius loci*, Paulus offers us entrée to secret and mysterious worlds, worlds directly adjacent to the mundane pathways of our daily lives.

Paulus is one of the later generations carrying on this grand pursuit. Please take your time while viewing this young man's entrancing images of these edifices and landscapes of curiosity and wonder. He has a very good eye, and, more importantly a powerful love and respect for these places that he has recorded for posterity.

R. F. Paulus's photos reveal these little acknowledged places, places that are unseen and out of mind. These "negative spaces"—corridors and rooftops, tunnels and crumbling factory floors, bunkers and bridge tops—are all a part of the infrastructure that supports us all, or that did at one time before the culmination of their useful lives and the beginning of the end. This parallel universe is inhabited by bold explorers and unapologetic psychogeographers, pursuing knowledge and in some cases recording brilliant and ghostly images of this secret world.

John Law
Original Member of San Francisco Suicide Club
Co-Author of *Tales of the San Francisco Cacophony Society*
Co-Founder of The Burning Man Festival
Crew member of Survival Research Labs & S. F. Cyclecide
Co-Owner of Laughing Squid

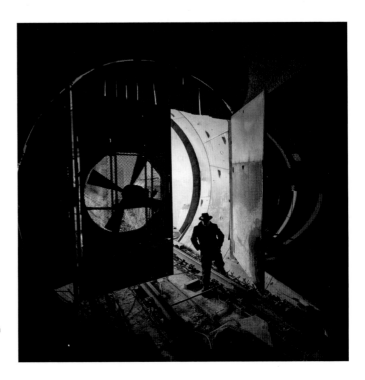

John Law stepping into an unfinished subway tunnel under San Francisco.

About the Author

R. F. PAULUS lives in San Francisco, California, after having grown up in Paris, France. His interest in photography and abandoned places started after exploring the centuries-old Paris Catacombs six years ago. Since then, he has traveled across many cities in North America, Europe, and Japan, as well as remote deserts in California, Nevada, and North Africa, in search of forgotten places and unique viewpoints to photograph. Besides photography, he has worked as an artificial intelligence researcher and software engineer in Silicon Valley for the past few years.

Introduction

Urban exploration is one of the most unique ways to discover, experience, and appreciate the man-made world we live in. It can make us rediscover our everyday environment with a renewed sense of curiosity. Each exploration is an unexpected journey to find hidden gems behind places that we might not have originally thought about.

My first encounter with the world of urban exploration started thousands of miles away from the San Francisco Bay Area, six years ago in the city of Paris, where I grew up. Many Parisians and travelers may be aware of the existence of a hidden place called the Catacombs of Paris, lying a few dozen feet beneath the surface of the city. I have always been vaguely aware of the existence of the catacombs, but having never seen it with my own eyes while growing up, it was to me, at best, an abstract notion, or at worst, a place that had to be avoided because of its dangers and alleged lack of interest. I thought the catacombs were not meant to be explored, but that changed after one of my friends told me about what he found there: 100 miles of centuries-old tunnels, a thriving community of artists, traces of Parisian history from the French Revolution to WWII, and many more interesting tidbits and points of interest. Following this revelation, and after a few weeks of my own research, I finally found an entrance that would lead me into this other side of Paris. Coming out of the catacombs, I knew I wanted to see more, and I started obsessively looking for more hidden locations to explore. I could not stop thinking about what I could find hidden from view in cities, and how to capture this different side of the urban landscape with photography, to show others what they might have been missing.

I kept that same attitude when I moved to the San Francisco Bay Area. Freshly arriving there while trying to develop my urban explorer mindset allowed me to discover this region in a vastly different way from what is usually portrayed. Exploring lesser-known and off-limits parts of the Bay Area was one of the best ways to get myself familiarized with this complex urban region. Ever since then, I have had the chance to meet several influential Bay Area explorers and personalities, forming long-lasting friendships, and have spent hundreds of hours researching explorable locations, and many more hours practicing my photography skills in the most unusual settings.

In addition to the rich history of the region itself, San Francisco saw the birth of many countercultural groups and movements in the later parts of the twentieth century, which also sought to experience urban areas in unusual ways, turning urban exploring into a subversive art form. Some of the most notable ones were the Suicide Club and the Cacophony Society, organizing parties in tunnels across the region, climbing on bridges, and eventually inspiring what would later become the notorious desert gathering, Burning Man. In many ways, the legacy of these movements lives on among urban explorers around the world, shaping the way they approach their environment, and trying to view the city in ways that most people would not think about.

This book blends artistic photos of the San Francisco Bay Area with personal stories about my exploring adventures, as well as historical insights about the region. With these personal and visual angles, I visit different social and economic trends that have influenced San Francisco from the nineteenth to the twenty-first centuries: the first population boom in the Gold Rush era, its rise as a maritime industrial hub, the war-time changes and influences, some sides of the hippie movements, and more recently, the technology industry boom and subsequent rapid social and demographic changes. All these trends have left visible marks in abandoned buildings across the region, active infrastructure above and below ground, as well as up-and-coming construction developments. This book shows these different narratives through rarely seen places, and reflects on what the future of the region could be in the next few years—what will be created and what might be lost. This will hopefully make us all appreciate the uniqueness of the San Francisco Bay Area even more than before.

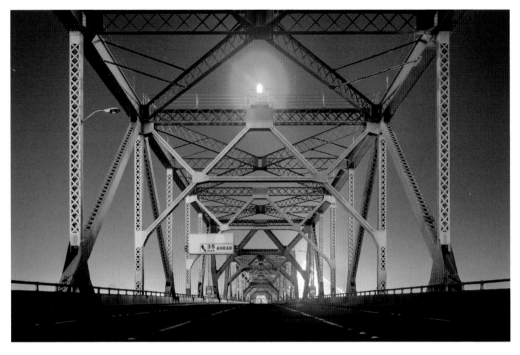

The abandoned Eastern Span of the San Francisco-Oakland Bay Bridge, during its ongoing demolition in 2014-2015.

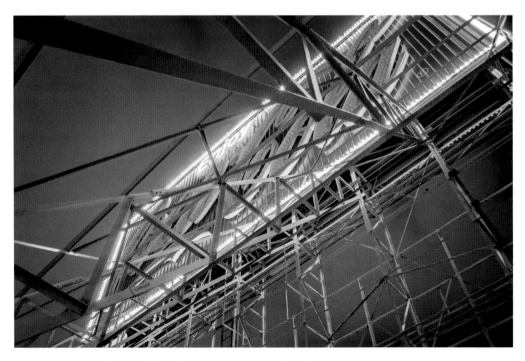

Getting close to an old neon billboard near a freeway in San Francisco.

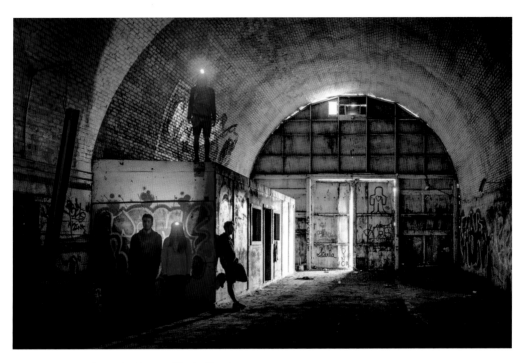

Entering a disused train tunnel in the Bay Area.

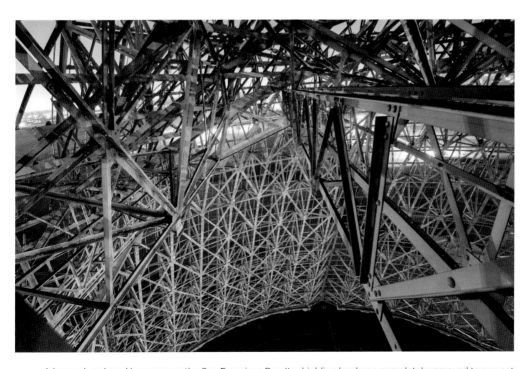

A large, abandoned hangar near the San Francisco Bay. Its shielding has been completely removed to prevent chemical contamination.

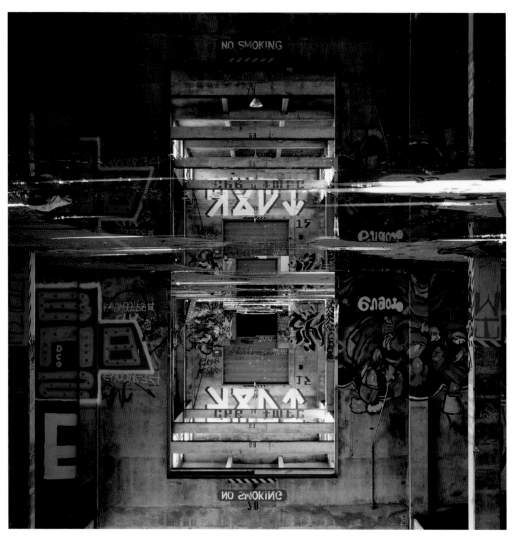

Playing with reflections and symmetry in an abandoned warehouse in a former military site.

1

Abandoned History

The most accessible locations for urban explorers to start are usually abandoned buildings spread around the city. Even in such an economically active place as the San Francisco Bay Area, where land use is in high demand, one can find abandoned structures of various sizes and antiquity in many corners of the region: from the lone disused building on a busy city block, to sprawling former military bases with an uncertain future, and large industrial buildings further from city centers. Peeking through these remnants of the past is where we start our journey through the hidden side of the Bay Area.

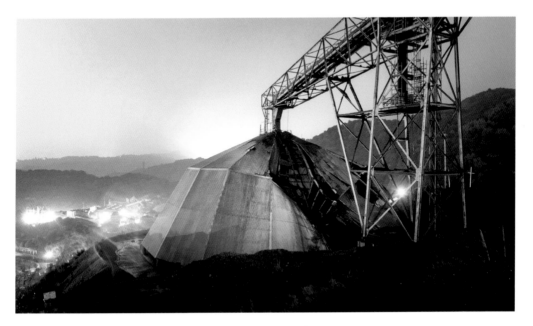

A half-demolished storage building, part of an active open-air quarry.

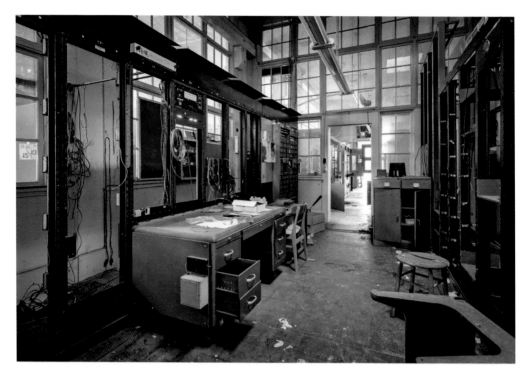

An abandoned radio station near the Bay.

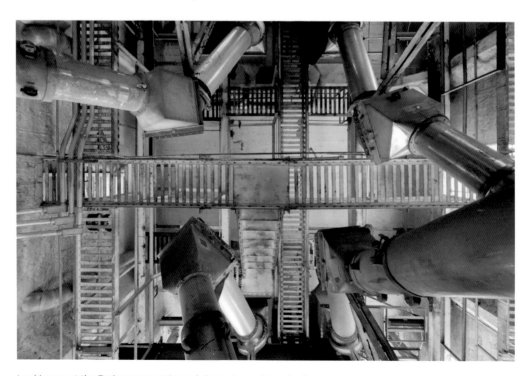

Looking up at the Escheresque stairs and chutes in an old grain silo.

Military Defense and Bunkers Around the Bay

While San Francisco has never been under attack from a foreign military since it became an American city in 1848, and even though the average San Franciscan does not feel under imminent military threat today, there are still traces of military defense structures spread all around the San Francisco Bay Area. Most of these structures date from the mid-1850s to the 1950s, taking us back to a time when the geopolitical future was more uncertain, and when a need for military defense was felt more visibly. The majority of these fortifications and bunkers are located along the ocean coast of the city and its surroundings, indicating the strategic importance of the ocean for San Francisco, and in particular the need to secure the Golden Gate strait as the main naval entryway into the region.

Being some of the oldest abandoned locations in the San Francisco Bay Area, many of these bunkers and defense batteries are well-known by locals, even becoming main attractions on some hikes in the northern Golden Gate area of Marin Headlands. Some, however, are harder to find, mostly because they are hidden among overgrown plants, or because their access has been made more difficult, but they all can be found with high accuracy on old military maps for the most dedicated explorers who want to obtain the most detailed information. A few of these bunkers, however, have definitely been locked or sealed by the authorities for preservation, making them completely inaccessible to the average explorer.

Today, some of these locations have become museums, like the oldest one, Fort Point, located under the Golden Gate bridge. Others have been turned into storage areas for various businesses, or have been left completely empty. The few that are still left open act as blank canvases for writers and artists. Once in a while, large-scale parties are organized there in relative secrecy, revealing an ephemeral art gallery or Halloween-themed night to a few hundred lucky visitors.

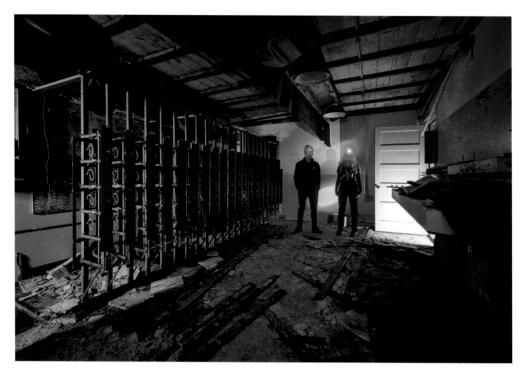

The switch room of a WWII-era underground bunker in San Francisco.

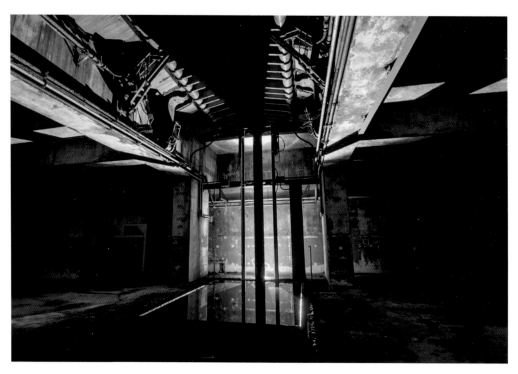

An underground Nike nuclear missile site.

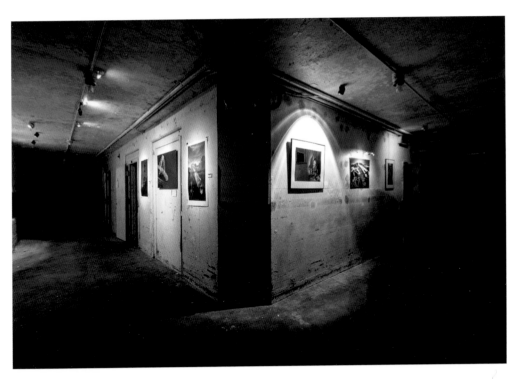

An ephemeral art gallery in an empty underground munitions storage complex.

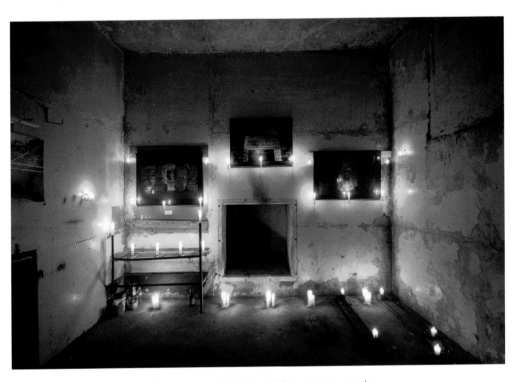

Dimly-lit temporary exhibition in an underground munitions storage complex.

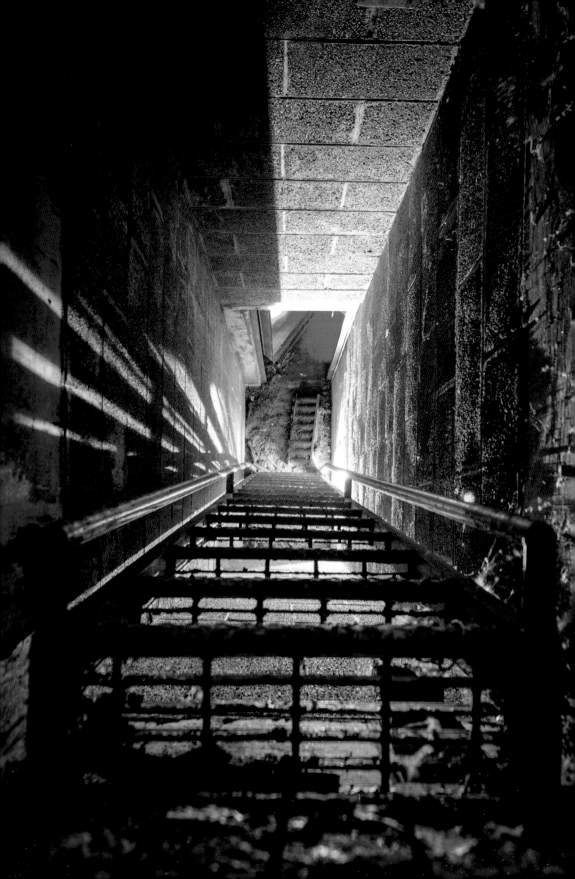

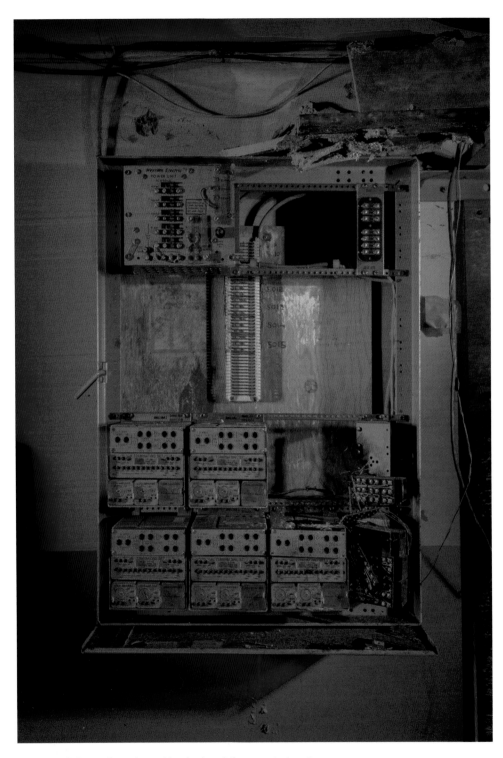

Disused electronic equipment in a harbor defense control post.

On the previous page: Looking down the entrance to a Nike nuclear missile site.

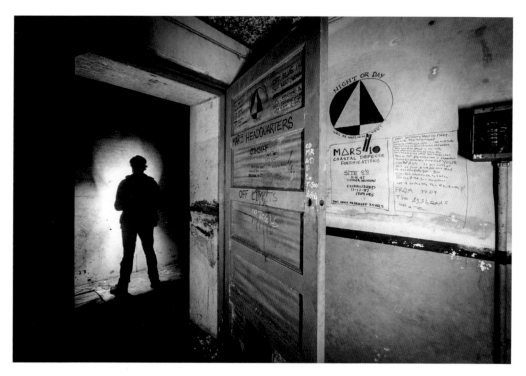

An abandoned underground military site outside of San Francisco, locally known as the "MARS bunker."

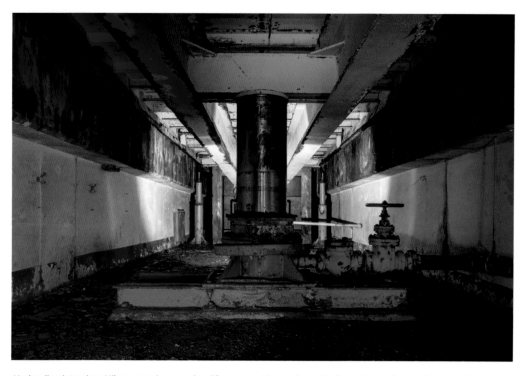

Hydraulic piston in a Nike magazine, used to lift up an entire nuclear missile to the surface before launch.

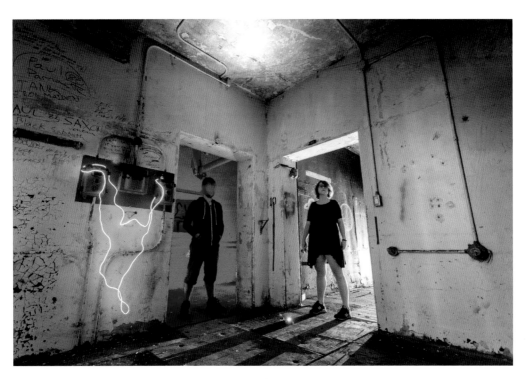

One of the many rooms of a munition storage complex in San Francisco.

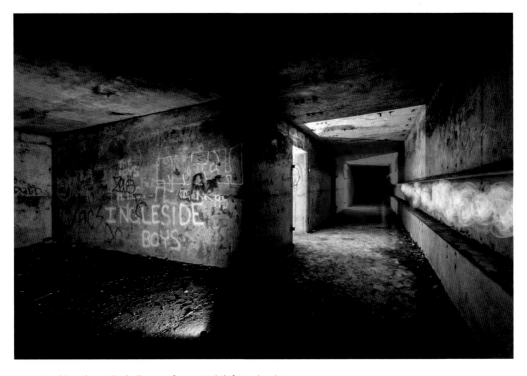

Looking down the hallways of a coastal defense bunker.

Hunters Point Naval Shipyard

In addition to its military defense systems, barracks, and bunkers, the San Francisco Bay Area was also home to a few naval bases in the second half of the twentieth century. One in particular, Hunters Point Naval Shipyard, was located on San Francisco's southeast side by the bay, and has been mostly abandoned since its closure in 1994. I was vaguely aware of the existence of this former base when I first moved to San Francisco, back when I was looking for places to photograph, but I stayed away from it for a long time because of safety concerns, until a friend convinced me to explore it together one evening in the summer of 2014. This ended up being one of the most rewarding trips I have taken in the city, culminating in experiencing the strongest San Francisco earthquake of the last twenty-five years, standing atop a 450-foot-tall abandoned crane overlooking the city.

This sprawling military base contains dozens of large warehouses, factories, military laboratories, barracks, and ship-building dry docks. Being one of the largest abandoned sites in San Francisco, separated from the rest of the city by steep hills, standing in the middle of this site feels like stepping into another world, with silent desert streets as far as the eye can see.

The scale of these installations and buildings reminds us of how significant the military and naval industries used to be for the region's economy. This military shipyard started in the 1940s and was mostly used as a ship repair facility and testing site. It was previously the location of a privately owned shipyard dating back to 1870. Some of the major landmarks of Hunters Point still visible today include the following:

- A six-story-tall multi-use building, almost entirely surrounded by glass windows, including a fully-transparent glass tower that was used for testing periscopes
- A small cube-shaped power substation near the shore
- A tall brutalist-looking barracks building on the edge of the base
- Many empty warehouses, each one having its own kind of architecture and interesting details
- Most notably, the Gun Mole Pier crane, a 450-feet tall four-legged gantry crane, the world's largest of its kind, built in 1947, and visible by anyone driving down the neighboring US-101 freeway. It was at one point the second tallest structure in all of San Francisco. One of its most extreme uses was intercepting dummy nuclear missiles launched from the ground, as part of a Navy test called Operation Skycatch

What also makes this site stand out (and was the cause of my early safety concerns) is its unusual radioactive toxicity. From 1946 to 1969, Hunters Point was chosen as the base where Navy ships conducting nuclear bomb tests in the Pacific Ocean came back to be studied and decontaminated. This was set up by a division of the Navy

named the Naval Radiological Defense Laboratory. Because the long-term effects of radioactivity were misunderstood and underestimated at that time, this operation led to a substantial radioactive contamination of the shipyard soil and buildings. Extensive decontamination work has been taking place after the site's closure, in order to make it safe and available for future developments. Despite new housing units opening up in 2015 near the site, and several other buildings being used by the police department and other organizations in the shipyard, the cleanup work has been taking longer than expected, making the future of the former base more and more uncertain. Considering that the nearby Bayview neighborhood, right across the hills from the shipyard, has been one of the most marginalized areas in San Francisco for the past few decades, the completion of this decontamination work is still badly needed.

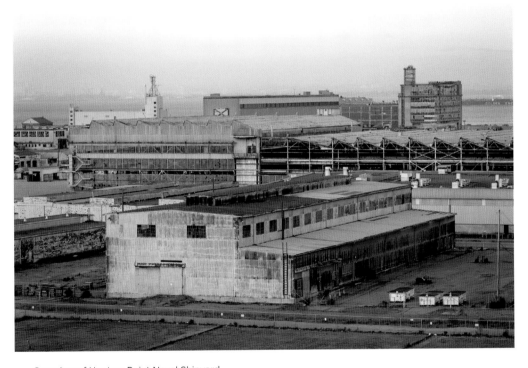

Overview of Hunters Point Naval Shipyard.

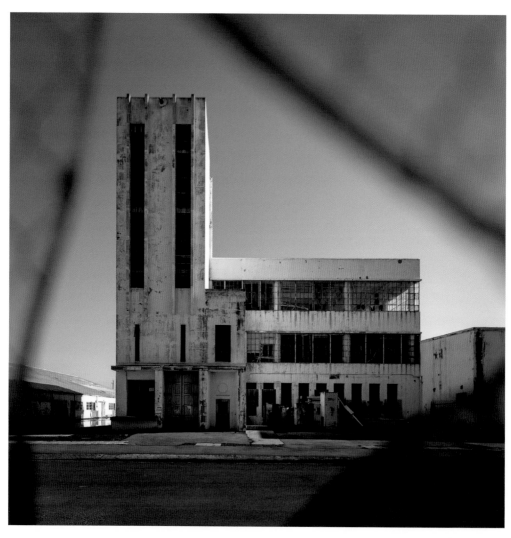

One of the many abandoned buildings in Hunters Point.

Inside a large, cavernous warehouse in Hunters Point.

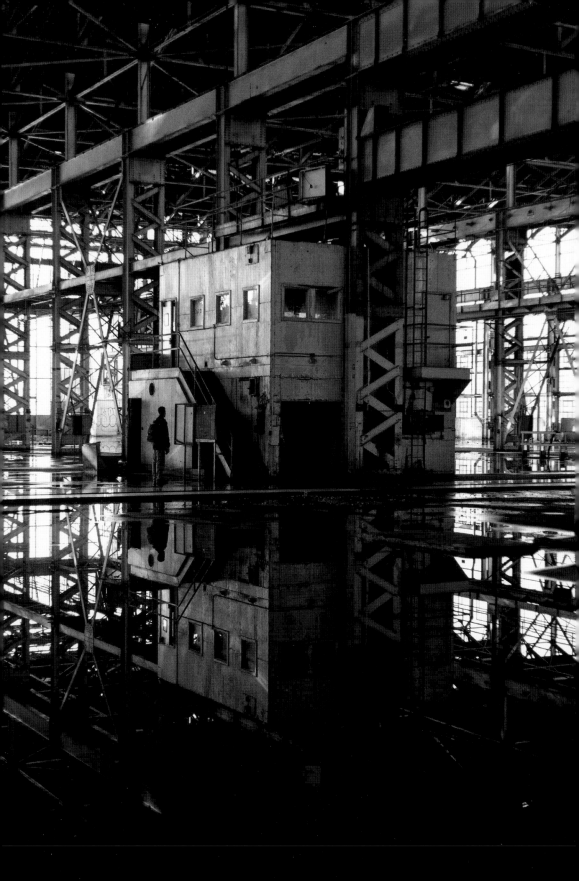

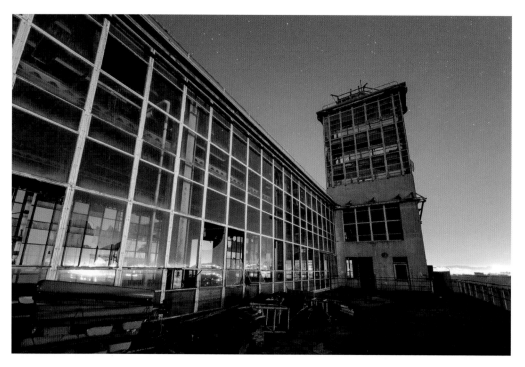

The most distinctive building in Hunters Point, nicknamed the "periscope building," because of its previous use as a periscope testing site inside the glass tower.

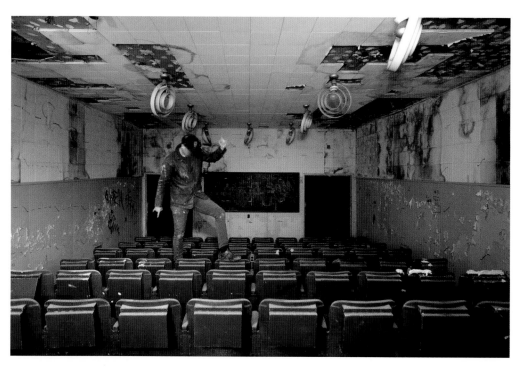

A military classroom in the Hunters Point periscope building.

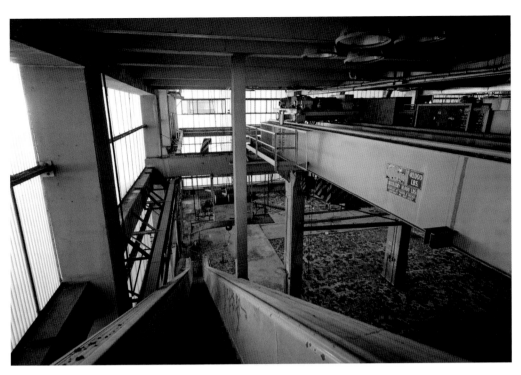

The world's largest indoor industrial escalator, sitting idle in a Hunters Point multi-use building.

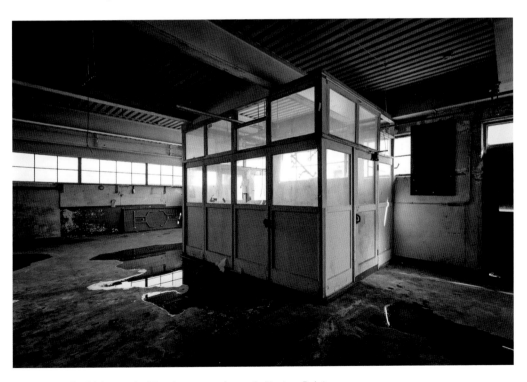

A small cubicle attached to a larger warehouse in Hunters Point.

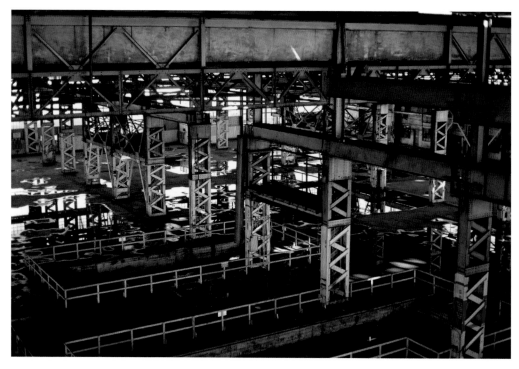

High viewpoint inside one of the Hunters Point warehouses.

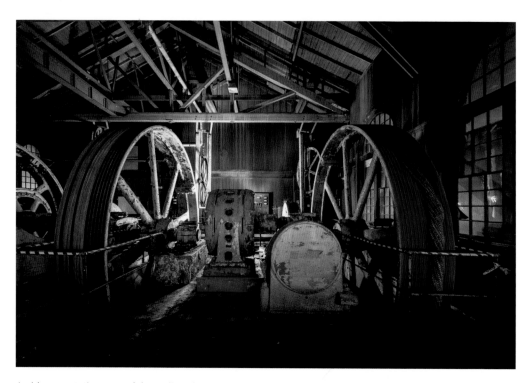

A old pump station, part of the earliest dry docks on the Hunters Point site, before it became a Navy base.

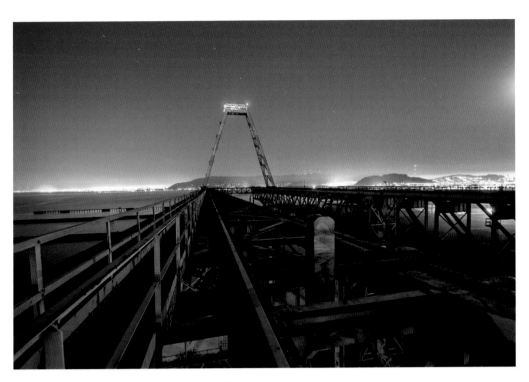

On the middle floor of the Gun Mole Pier Crane.

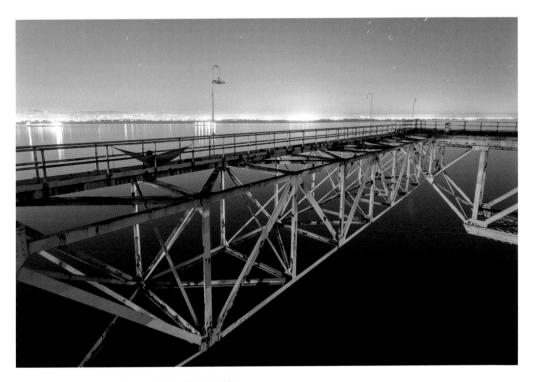

An instance of not-so-extreme hammocking.

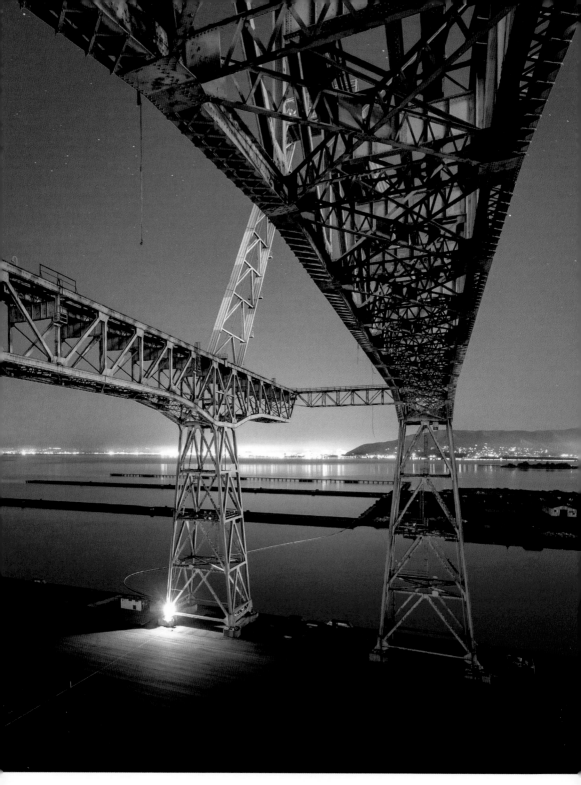

Looking from inside one of the legs of the Gun Mole Pier crane, showing the other Hunters Point piers in the background.

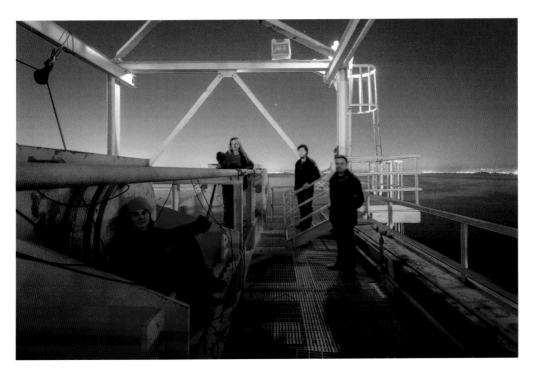

Atop the Hunters Point gantry crane.

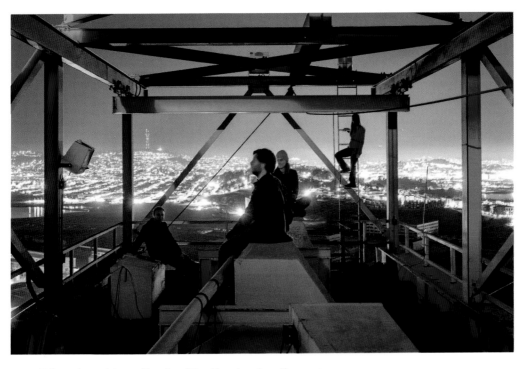

Unique viewpoint over the city of San Francisco from the crane.

Industrial San Francisco: the Dogpatch Area

Similarly to Hunters Point, many abandoned buildings in San Francisco are located on the southeastern side of the city, around an industrial neighborhood known as the Dogpatch. This area has kept a very different feel from the rest of San Francisco for a long time, developing at a slower pace with its more industrial culture. One of the most prominent sites in this area is the Pier 70 shipyard, the largest civilian industrial complex in San Francisco for most of the twentieth century, operated by Bethlehem Shipbuilding. At its peak, the Pier 70 shipyard produced sixty-six destroyers and eighteen submarines during World War I, and fifty-seven different ships during World War II. But the shipyard ultimately lost ground to domestic and international competition, which led Bethlehem Shipbuilding to sell it the Port of San Francisco for the symbolic price of one dollar in 1982. This former site is still easily recognizable in the city skyline by its various shipbuilding cranes, which even made an appearance in a scene of Alfred Hitchcock's classic movie, *Vertigo*.

Following the industrial decline of the area after the 1980s, many shipyard buildings were either left abandoned, used as artists' studios, converted into tech company offices, or turned into event venues. One of these abandoned warehouses by the bay, often called "Warehouse 6" by urban explorers, was a notable venue for unsanctioned events like raves, hosted a makeshift skatepark, and was temporary home to two grand pianos. Besides the warehouses and former factories, a couple of dry docks from the original shipyard were still under operation by a different company, until they suddenly ceased operations in 2017.

For the past ten years, following a redevelopment effort, and pushed by the overall growth of the San Francisco Bay Area, many of the historic buildings of this area have been renovated with an effort to preserve their historic character. Change is still underway, and the entire Pier 70 area is undergoing a comprehensive redevelopment project to be completed in 2022, closing a chapter of industrial Dogpatch history at the same time.

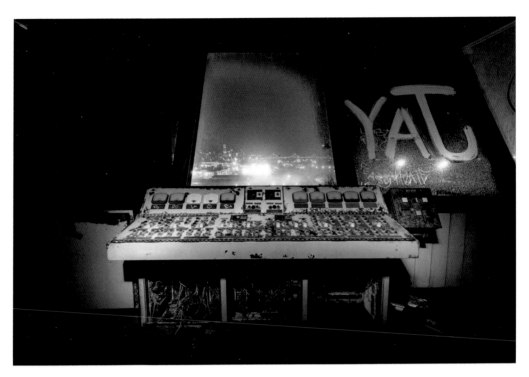

An old control desk in an abandoned grain silo.

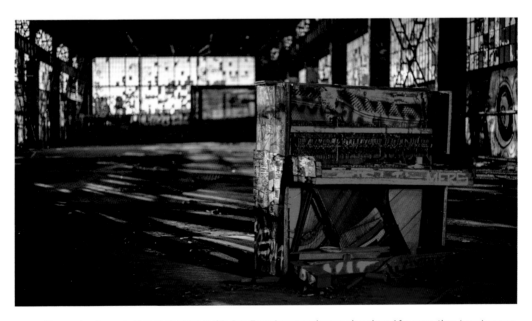

Remnants of a party that took place in this San Francisco warehouse, abandoned for more than twenty years.

Sunbathing on top of an abandoned grain silo.

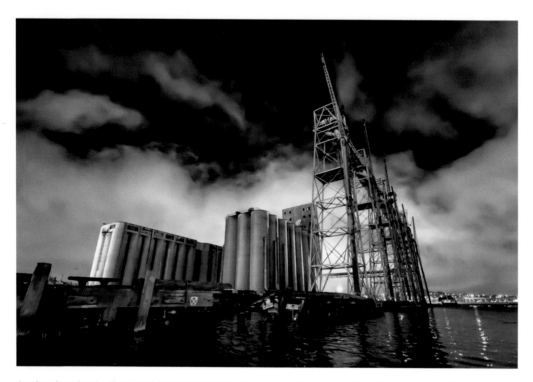

An abandoned grain silo viewed from an inflatable raft at night, with the typical San Francisco fog taking over.

Playing with shadows and contrasts on the side of an abandoned warehouse.

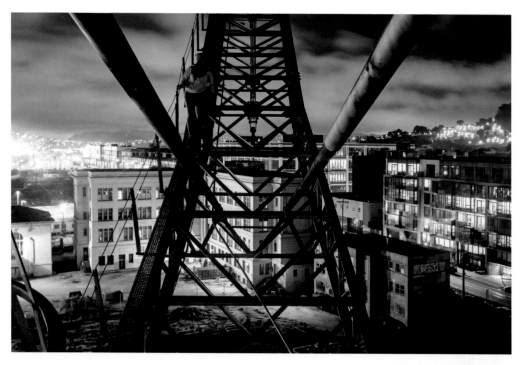

A now-demolished shipbuilding crane, with the former headquarters of Bethlehem Shipbuilding in the background.

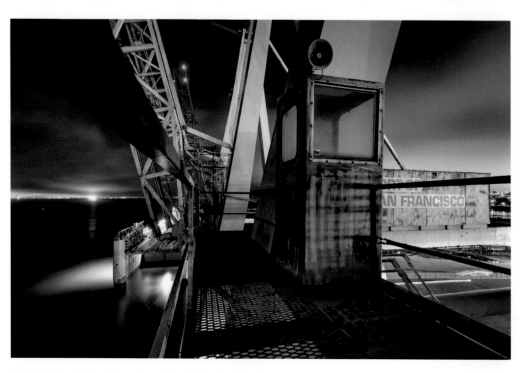

A modern container crane sitting idle in the port of San Francisco.
On the next page: Looking down container cranes in the port of San Francisco.

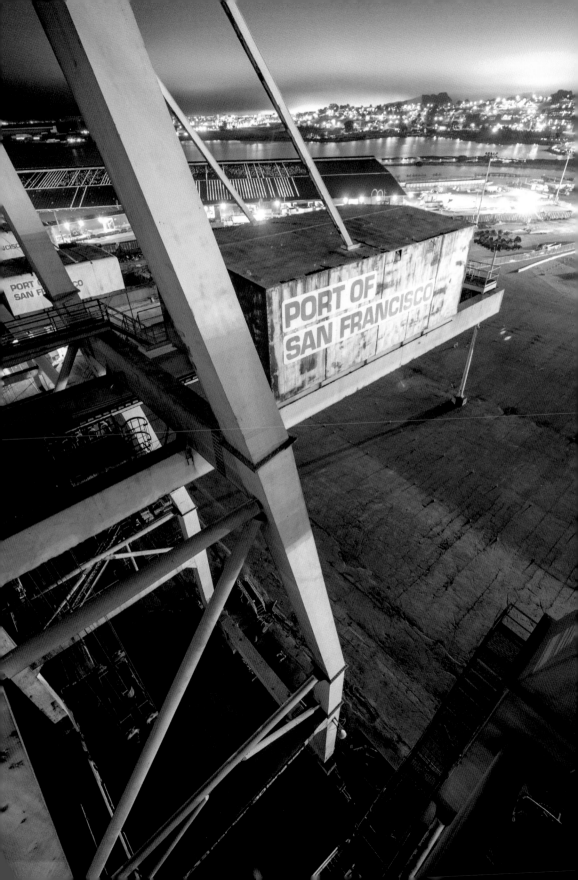

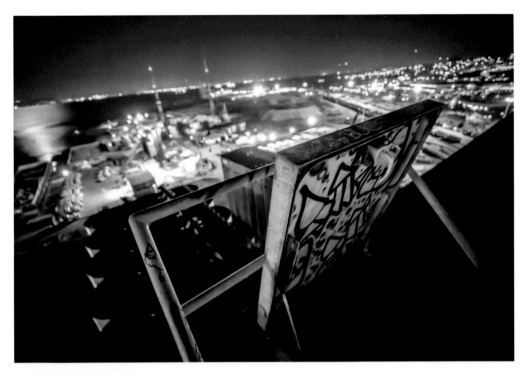

View from above the roof access hatch of an abandoned grain silo.

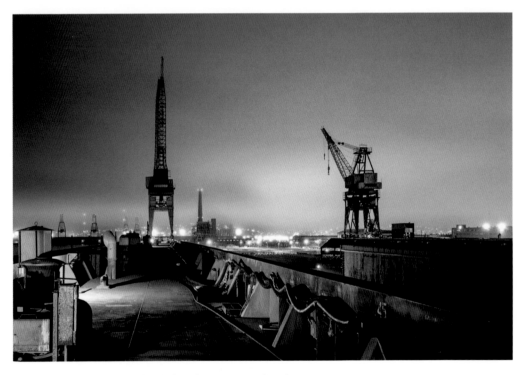

A recently decommissioned dry dock, with cranes at each end.

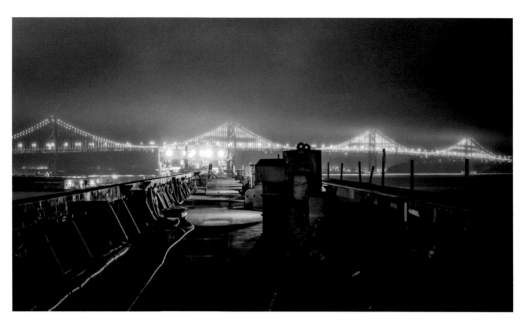

Looking at the San Francisco-Oakland Bay Bridge from a decommissioned dry dock.

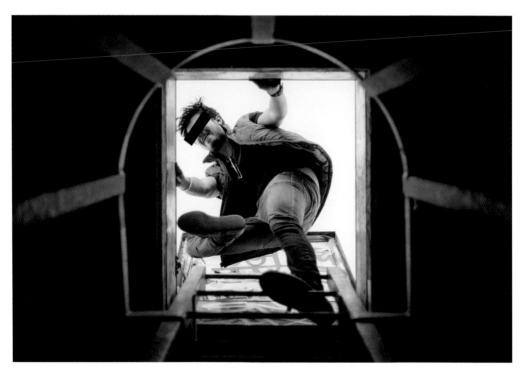

View from below the roof access hatch of an abandoned grain silo.

Other Abandoned Locations in the Bay Area

Beyond the large-scale military and naval industrial sites in the San Francisco Bay Area, a slew of other industries left their mark on the region. From abandoned mental hospitals, steel mills, disused train tunnels, former retail giant headquarters, and other historically significant buildings, exploring the San Francisco region in search of these locations reveals the diversity of its economy in the past decades, but also shows the dramatic economic changes that led to such closures.

After such closures and abandonments, the days of these buildings are often numbered. Even when they have been sitting empty and unused for years, they might still not survive the intense growth and redevelopment efforts of the region, which makes their exploration and documentation even more worthwhile. As of 2020, some of the buildings pictured in this chapter have already been demolished, or underwent significant changes in order to be repurposed.

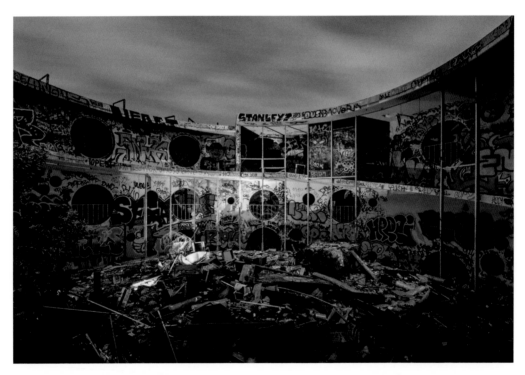

Housing barracks known as the "Asterisk building" on Treasure Island, now demolished.

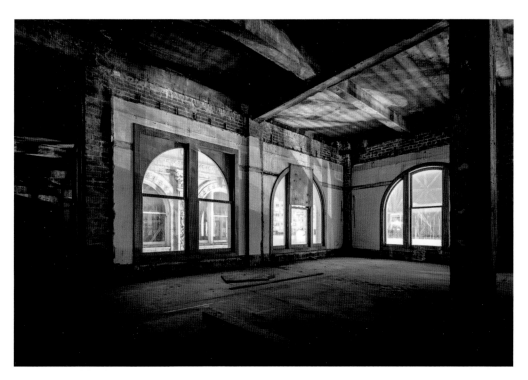

A historic building in downtown Oakland, emptied out and awaiting renovation.

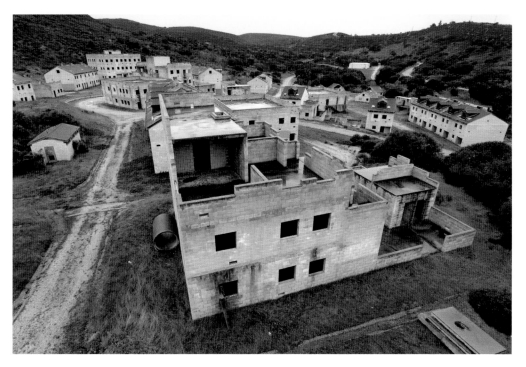

A military training site, simulating elements of Middle Eastern villages, on the outskirts of the San Francisco Bay Area.

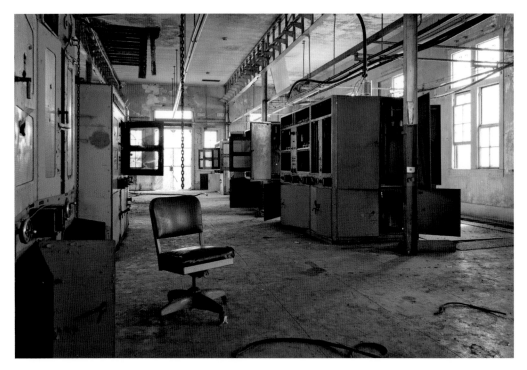

Disused equipment in an abandoned radio station.

The morgue of a former mental hospital in San José.

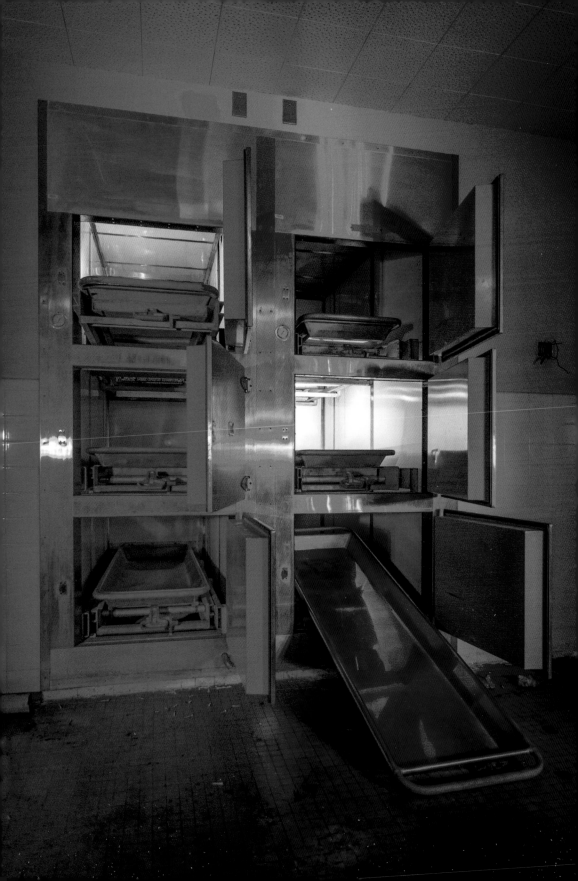

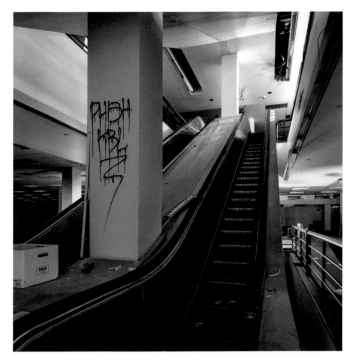

Elevators between floors of the former headquarters of the department store Mervyn's in Hayward.

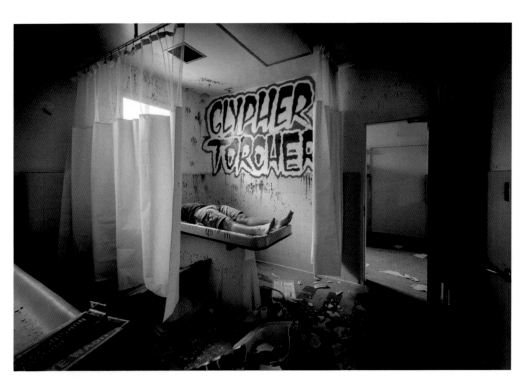

Dramatically posing in a former mental hospital in San José.

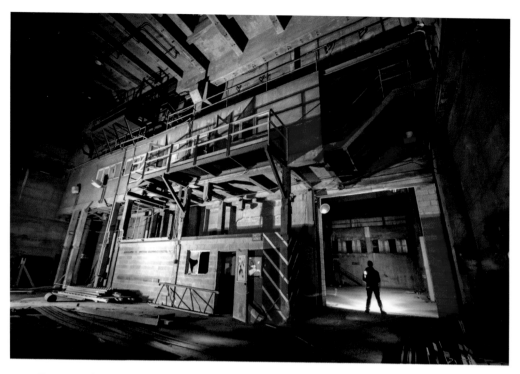

Former steel manufacturing complex, a stone's throw away from the bustling Silicon Valley.

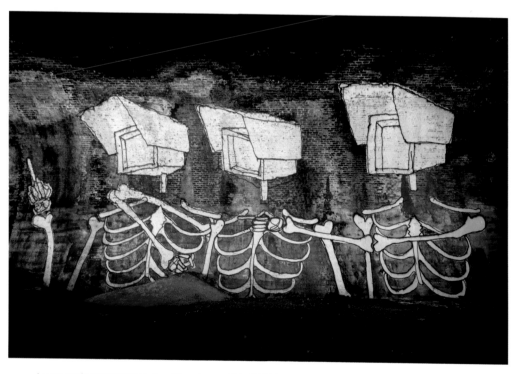

Large-scale painting from local Bay Area artist CCTV, in an abandoned train tunnel.

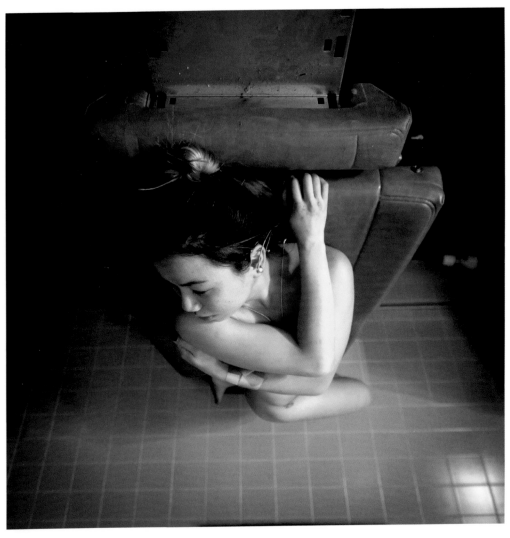

Well-preserved operating room in a former mental hospital in San José.

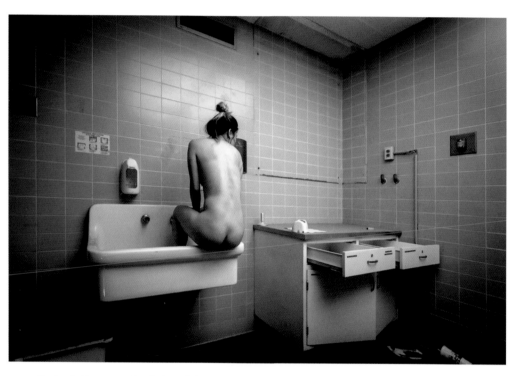

Playing in the remnants of a hospital room.

Bas-relief details on a historic building in downtown Oakland.

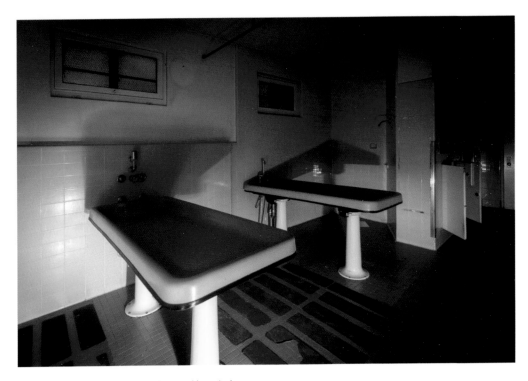

Washing tables in an abandoned mental hospital.

2

Active Infrastructure

The most dedicated urban explorers rarely limit themselves to buildings that are simply abandoned. For all their variety and depth, exploring these locations is barely scratching the surface of the hidden urban landscape. Another dimension opens up with the thorough mapping and exploration of active infrastructure. More challenging to access and photograph than abandoned buildings, active infrastructure can tell us more about the present of the city, its operating challenges, needs for growth, urbanism, and compromises made to accommodate a growing population. And sometimes, the adventure necessary to get to the heart of an iconic piece of infrastructure, and seeing it under completely new angles, is well worth the challenge, and grows bonds between fellow explorers through adversity and collaboration. Whether they are well-known or hidden underground, these man-made structures are often impressive by their scale, sometimes dangerous to access, but always rewarding to see in depth. I have found them to be some of the most intense places to explore and photograph in San Francisco.

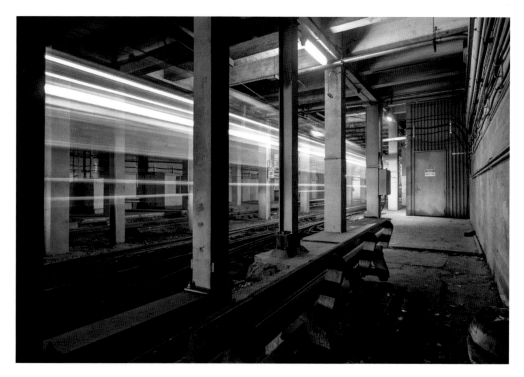

Local trains passing by without stopping in an abandoned subway station in San Francisco.

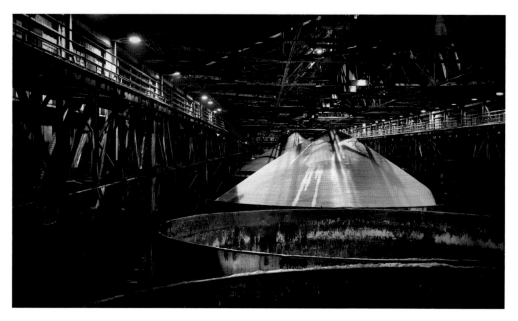

Piles of sugar overflowing from silos in a factory.

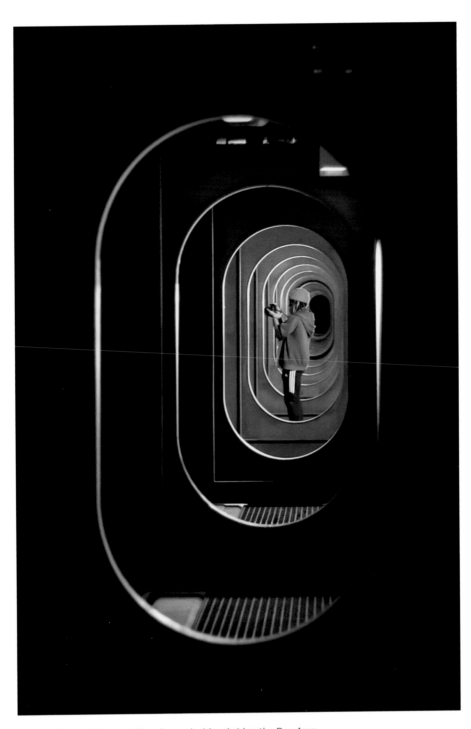

Looking through the repetitive shapes inside a bridge the Bay Area.

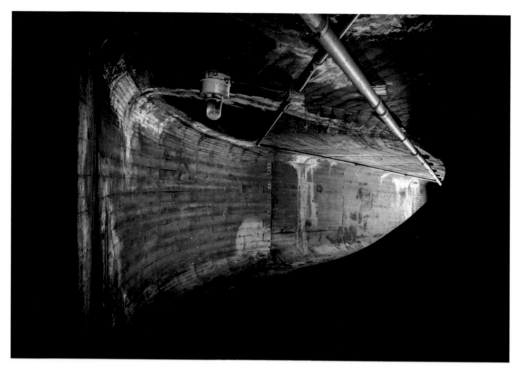

Large ventilation tunnel under the Bay.

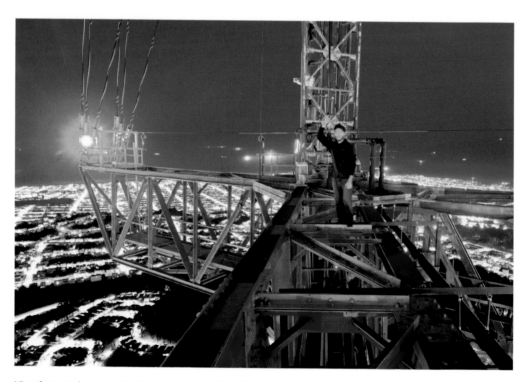

View from a telecommunications tower in San Francisco.

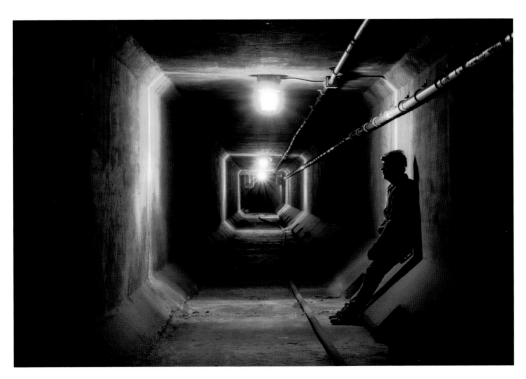

Looking straight down a ventilation tunnel under the Bay.

The surface section of a vertical ventilation shaft, connected to a road tunnel below.

Storm Drains and Sewers

Our first look at the active infrastructure of the Bay Area takes us below ground. Under the city of San Francisco lies a vast network of tunnels, reaching through every corner of the city, which has been existing under one form or another for more than a century. Often mythicized by would-be explorers who have heard rumors about it, this network is in fact the San Francisco sewer system. At first a small-scale network of Gold Rush-era sewers flowing into increasingly polluted rivers, this became a well-planned system of brick and concrete tunnels, buried creeks, flood control structures, and pump stations, all connected by a complex maze across multiple watersheds. While the majority of this system is hard to access without proper equipment and safety training, a glimpse at a few sections of this system can help us comprehend the scale of its operations, and the hidden wonders of engineering behind it.

Because of its consequent antiquity, this sewer system was built as a combined storm drain/sewer system, meaning that rainwater runoff from the streets usually flows to the same collectors and sewer lines as sanitary sewers. This was a simpler system to design originally, but it came with environmental complications during heavy rainfall events. When rainstorms occur, the system has to dump water and sewage overflow in the San Francisco Bay and the Pacific Ocean, through designated overflow sections. To prevent this chronic ocean pollution, sewer engineers later built massive transport and storage tunnels, which reduced the need for dumping by instead storing large quantities of storm water and sewer in large-scale concrete tunnels, before being processed by treatment plants. These storage tunnels and the overflow sections are some of the most impressive and photogenic features of this sewer system, but are also only accessible in dry weather when the water level is low enough.

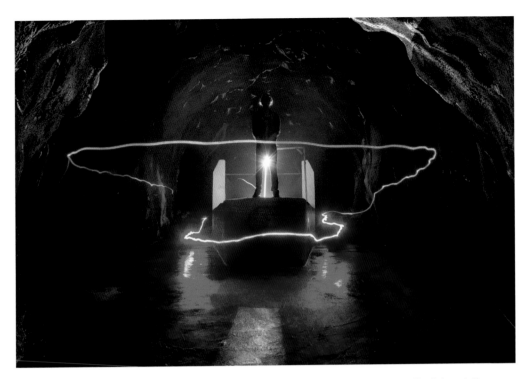

A junction room between the San Francisco sewer system and the ocean, accented by light-painting.

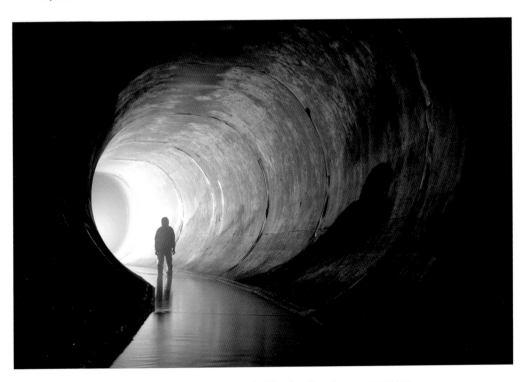

Standing in the curve of a large transport tunnel of the San Francisco sewer system.

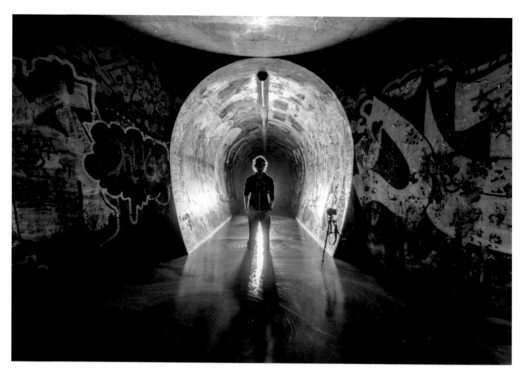

One of the most graffiti-covered sections of the San Francisco sewers, close to a popular beach.

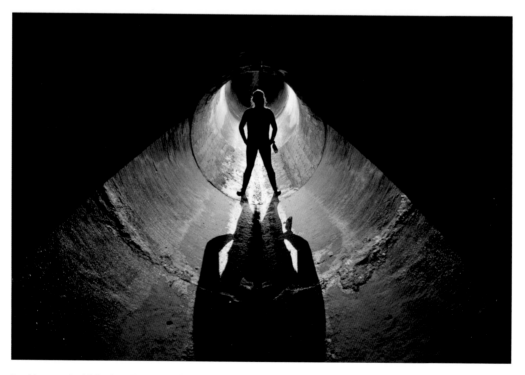

Looking up at a high-elevation point of the San Francisco sewers, making this section drier than usual.

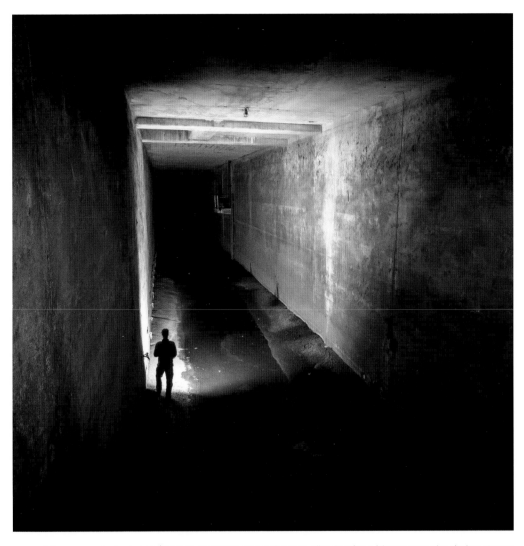

A large sewage transport/storage structure along the Bay, allowing for a bigger capacity during storms and large rainfalls.

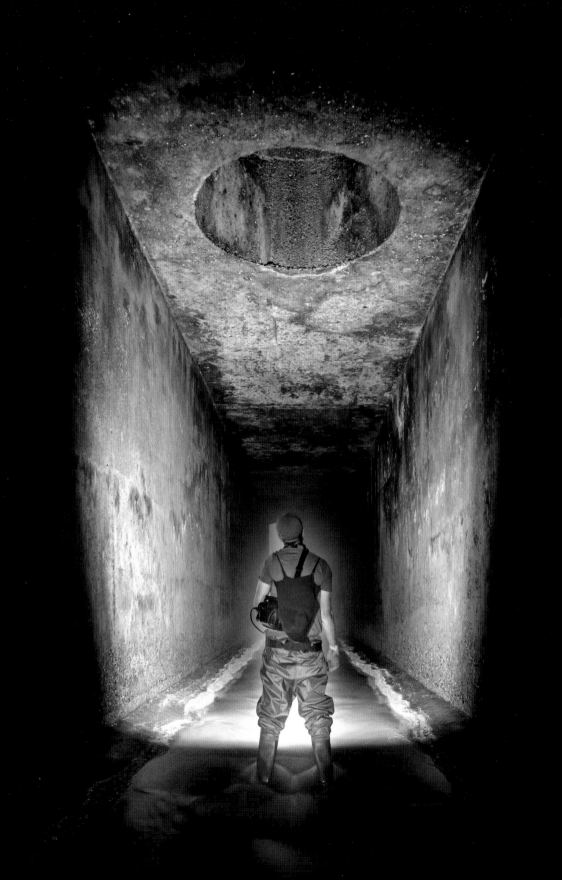

Outside of San Francisco, newer cities in the rest of the Bay Area use separate systems for storm rainwater and sewer, in order to avoid the environmental and logistical issues of a combined system discussed before. The newly built storm drains usually follow existing waterways such as creeks, sometimes turning entire natural creeks into covered concrete channels. These storm drains are usually more spacious and walkable than sewers, which make them more pleasant to wander around and photograph. During my visits down these storm drains, I have encountered prominent local graffiti artists, other photographers, choir singers enjoying the unique reverb of a particular concrete section, and even found a bank robber's stash on a notable occasion. But when winter comes and marks the end of the dry season, the rainwater in storm drains will wash everything that was left in them, making them unpredictable and extremely dangerous to explore.

A storm drain intake in the San Francisco Bay Area during the dry season. The metal beams prevent large debris from getting inside.

Exploring the outfall of a deaeration chamber in the San Francisco sewers.

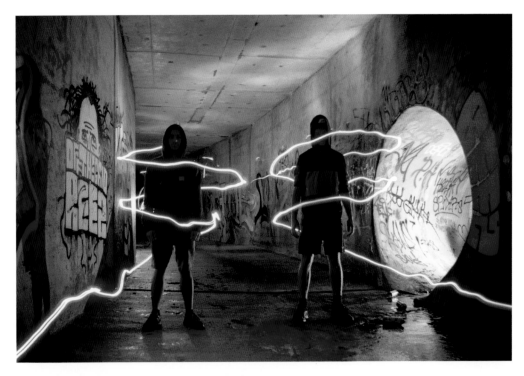

Playing with lights at an underground junction in a storm drain.

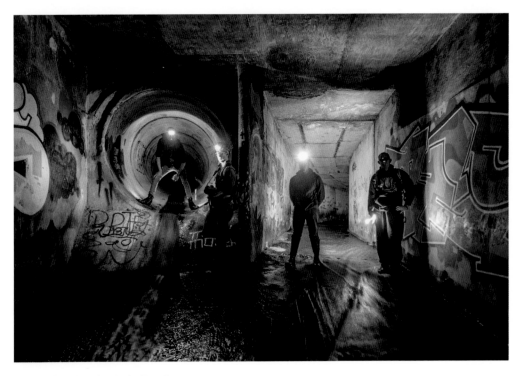

A storm drain junction in the East Bay.

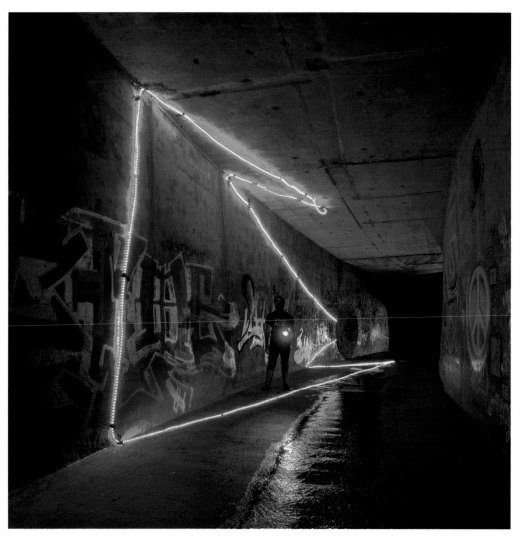

Anamorphic art installation in a storm drain. Viewed from a different angle, the lights align to form a perfect triangle.

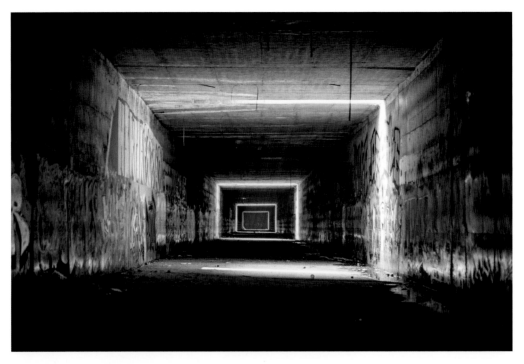

A dry underground river overflow drain in San José. The construction of this drain was necessary to prevent the Guadalupe River from flooding.

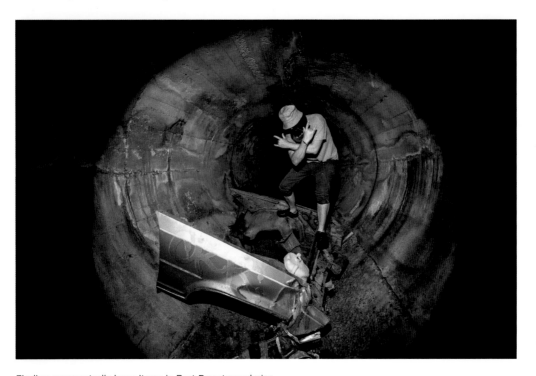

Finding unexpectedly large items in East Bay storm drains.

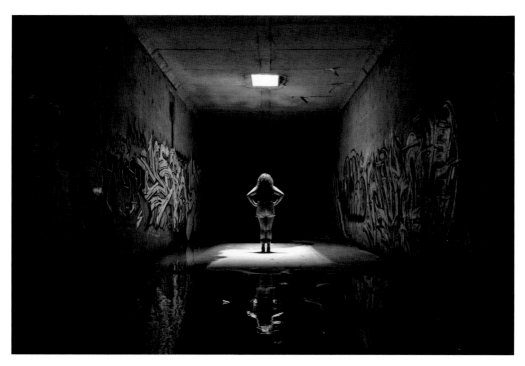

One of the only natural light sources in this miles-long storm drain.

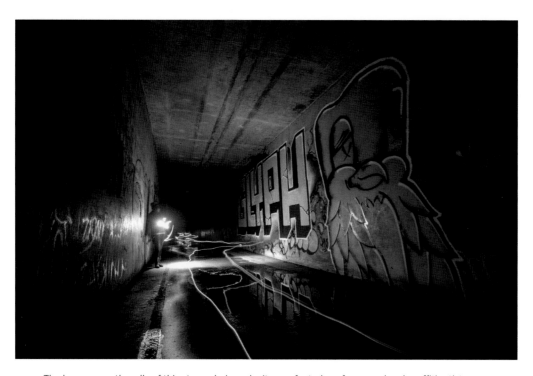

The large, smooth walls of this storm drain make it a perfect place for many local graffiti artists.

Power Plants and Stations

Above ground, power plants constitute one of the most significant pieces of infrastructure. They remind us that the electricity we usually take for granted requires in fact massive and complex structures that few of us understand in detail. Even though some power plants and generating stations used to operate close to population centers, today they are pushed away in more remote areas for environmental and cultural reasons, which leaves some former power plants decommissioned or abandoned in urban areas, making them easier to access and photograph for urban explorers.

The energy powering the San Francisco Bay Area today comes from a variety of sources, but increasingly from renewable ones, like wind farms in the Diablo Range and Montezuma Hills in the East Bay, hydroelectric dams from the remote Sierra Nevada mountains, geothermal fields on the northern limits of the Bay Area, and a few megawatts worth of solar panels spread throughout public and private city buildings. However, the few abandoned power plants that are left to explore today were rarely using renewable sources—they burned natural gas or diesel fuel instead. They are a reminder of the environmental price that early San Franciscans had to pay to get access to reliable electricity and make the growth of the past 170 years possible. Today, one such former natural gas power plant on the eastern side of San Francisco has been decommissioned since 2010, and awaiting the start of a construction project that will turn it into an upscale hotel, while preserving its original earthquake-resistant outer structure and recognizable smokestack.

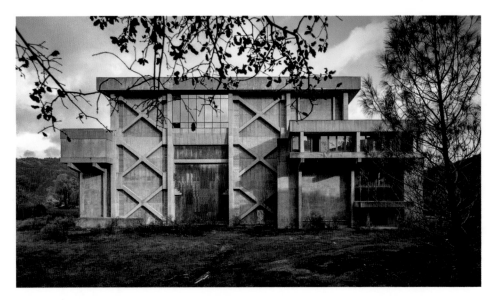

Facade of an unfinished geothermal plant, on the outskirts of the San Francisco Bay Area.

On the next page: Looking down through an abandoned power station in San Francisco.

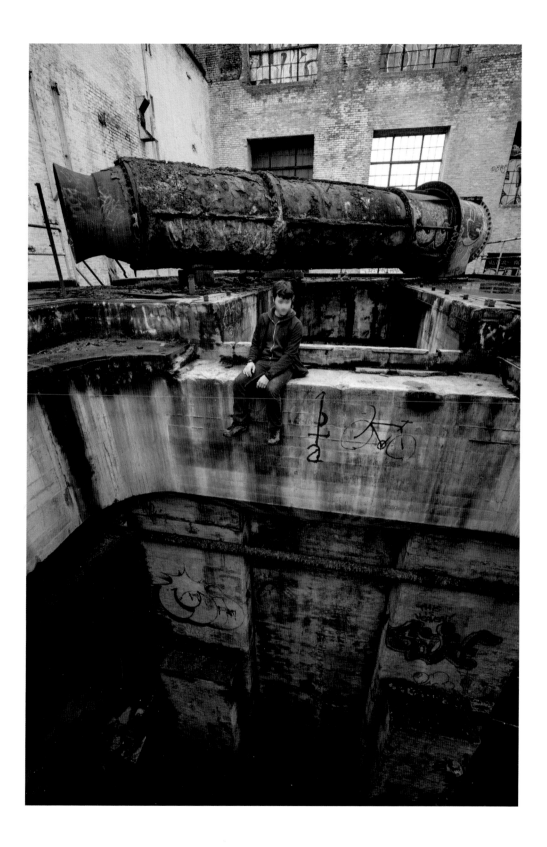

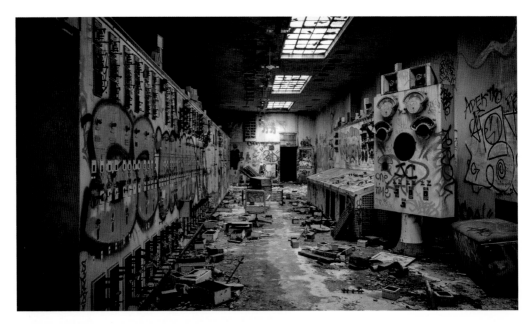

Control room of an abandoned power station in San Francisco.

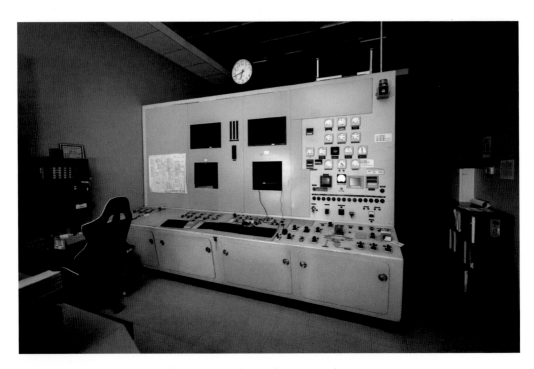

Well-preserved control room in a decommissioned natural gas power plant.

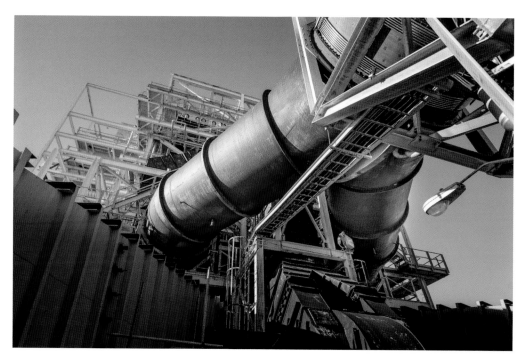

Exhaust air ducts connecting to the cooling tower of a decommissioned power plant. Future development plans for this building would create walkways inside these large air ducts and turn the rest of the power plant into a hotel.

Cooling structure of a small power station in an abandoned naval base.

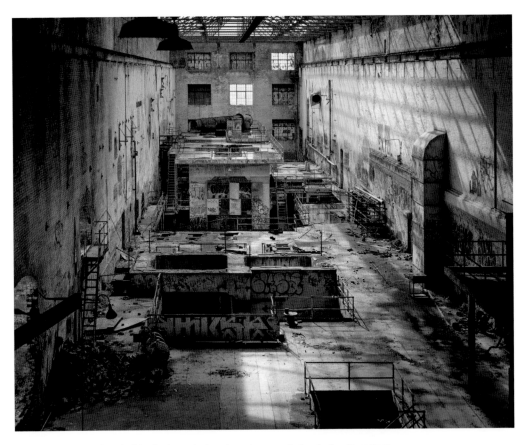

Overview of the turbine hall in the largest abandoned power station in San Francisco.

Unfinished intermediate floors in a geothermal power plant.

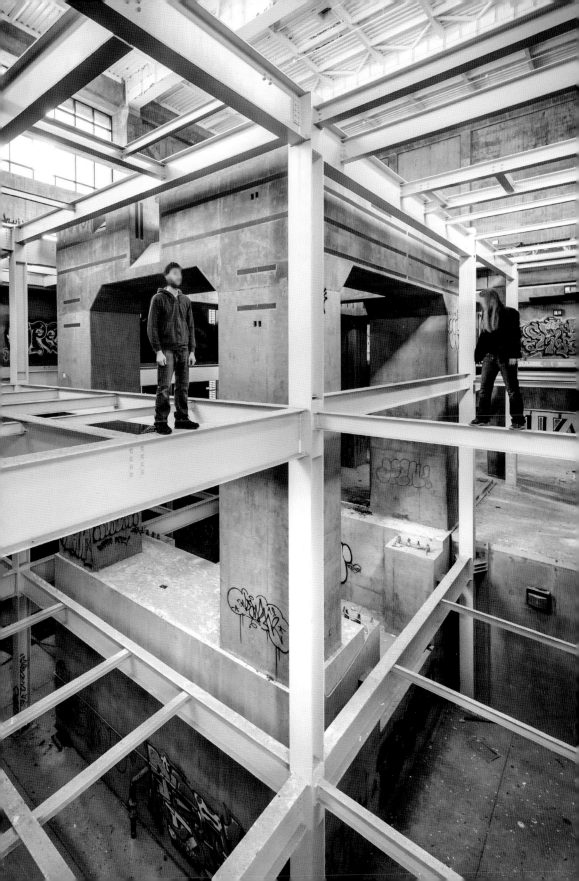

Analog technology in the turbine hall of an abandoned San Francisco power station.

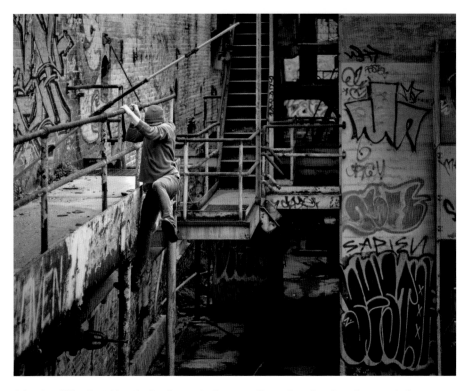

A local graffiti artist taking the hard route to the upper floor of an abandoned power station.

Hand-powered technology near the control room of an abandoned San Francisco power station.

Bay Area Bridges

Ask anyone around the world to name a man-made structure that represents San Francisco or California as a whole, and you will likely hear the name of the Golden Gate Bridge before any other. While this iconic bridge is still an essential part of the city and a beloved monument, the San Francisco Bay is crisscrossed by nine other large bridges, all serving critical purposes in a geographically unique region.

During its early history, San Francisco's lack of bridges connecting it to the rest of the Bay Area was a significant hindrance to its urban development, and reinforced its isolation from the rest of the United States. This all changed with the opening of the region's two major bridges, the San Francisco-Oakland Bay Bridge and the Golden Gate Bridge, a year apart from each other in 1936 and 1937. Since then, several other crossing points have made the whole Bay Area more interconnected at a regional level, allowing for faster commutes, growth, and development. The busiest of all, the Bay Bridge, carries approximately 278,000 vehicles per day, which is more than a third of all traffic on all of California's state-owned bridges combined.

What makes the Bay Area bridges so interesting for photographers is their diversity of architectures and designs: cantilever, vertical lift, suspension, truss, segmental, and some blending two or more designs in creative and surprising ways. They provide a never-ending supply of interesting angles and artistic inspiration.

A major turning point in the history of bridges in San Francisco happened in 1989, with the Loma Prieta earthquake that created severe damage across the entire Bay Area. The most notable of these damages was the collapse of a section of the Bay bridge between Yerba Buena Island and Oakland. Following this incident, government officials and engineers ordered a review of the design of all the bridges in the region, fearing that they might not withstand the impact of large earthquakes in the future. In the following years, extensive seismic retrofit projects took place in some sections, replacing beams and strengthening piers, while the entire eastern span of the Bay Bridge was bypassed by a brand new section opening in 2013, leading to the subsequent demolition of the old span.

Night-time view of the iconic San Francisco Bay Bridge, showing the San Francisco skyline before the construction of the Salesforce Tower.

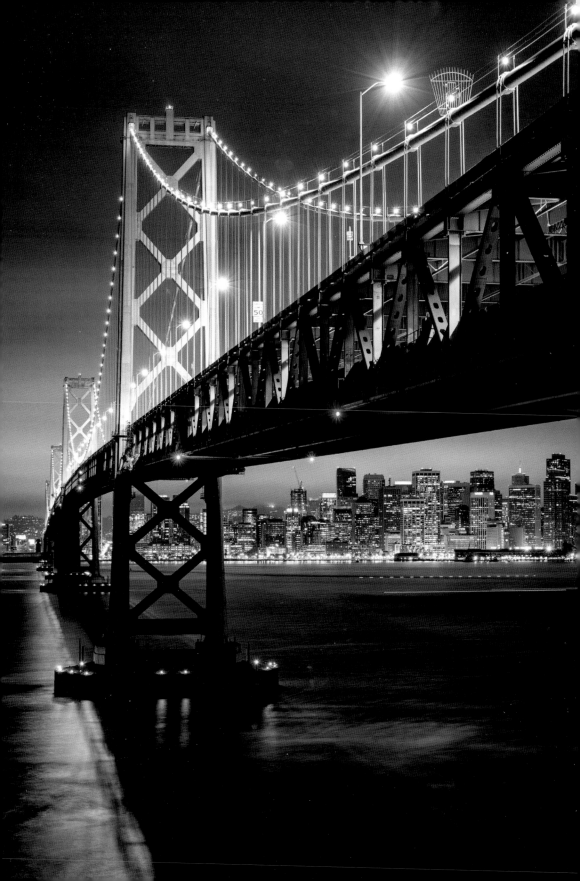

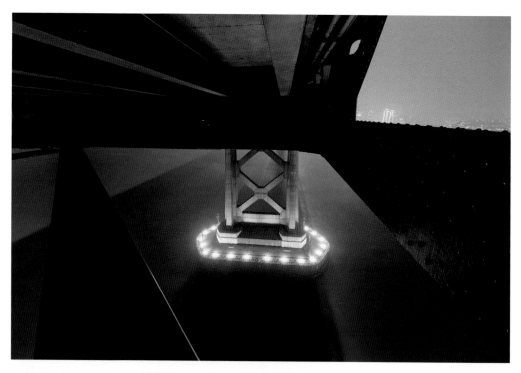

Getting close to one of the towers of the San Francisco Bay Bridge.

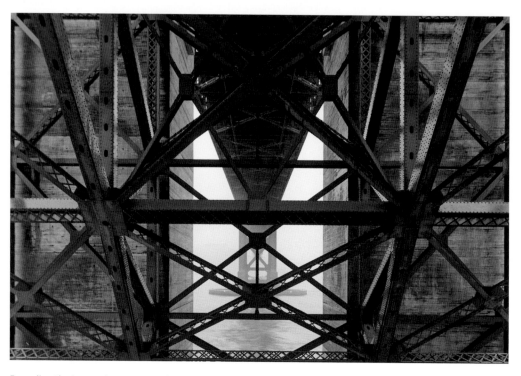

Revealing the ironwork symmetry of the Golden Gate Bridge.

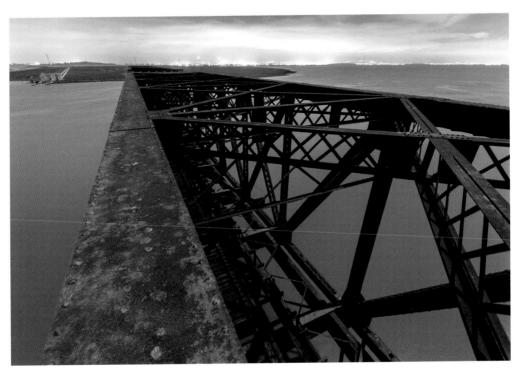

The first bridge built to cross the San Francisco Bay, originally designed for commuter trains, now completely out of service.

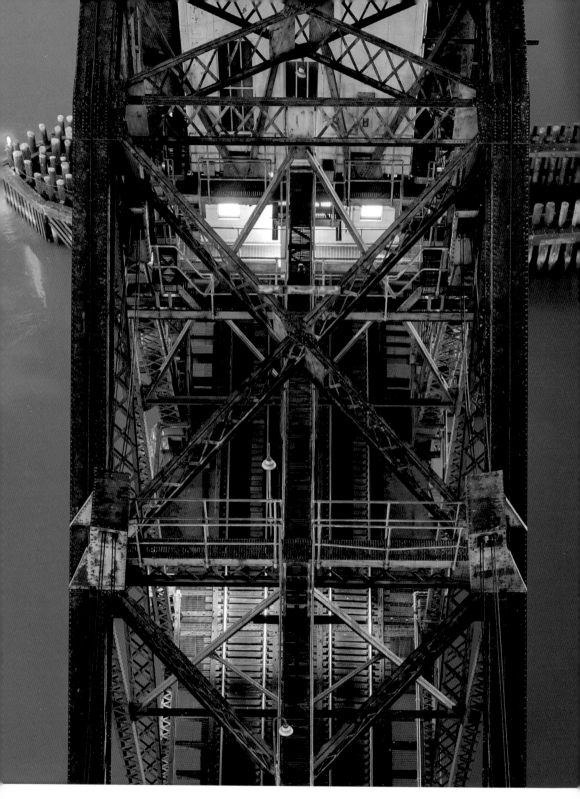

Close-up of a vertical-lift train bridge, with the operator booth sitting on top of it.

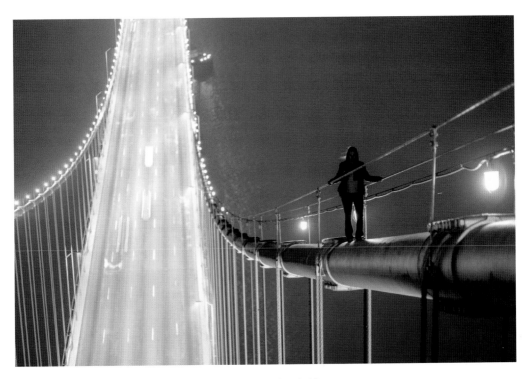

Riding the suspension cable of a San Francisco Bay Area bridge.

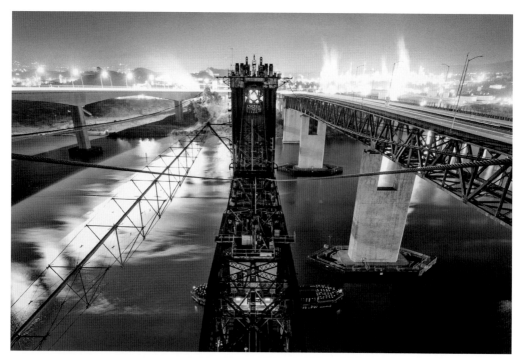

A trio of bridges, two road bridges and a train one, passing over a strait leading to the San Francisco Bay.

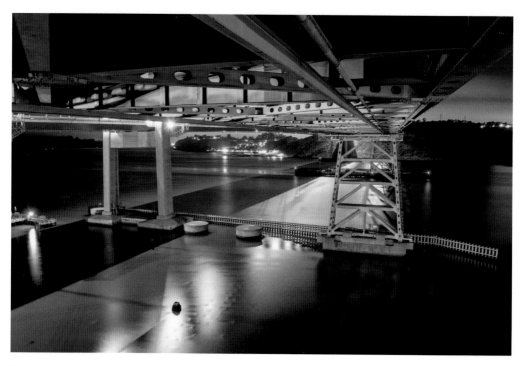

Close view of underneath twin bridges passing over a strait of the San Francisco Bay. Remnants of a now demolished third bridge can be seen in the water between the existing two.

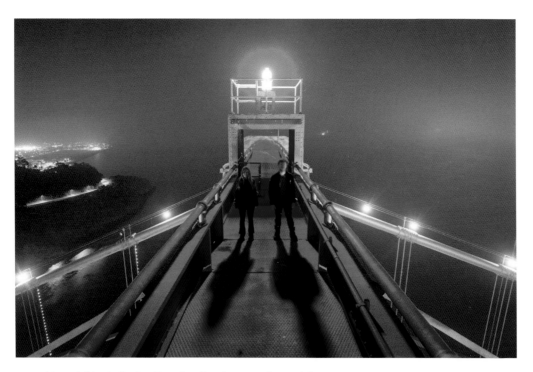

Atop a bridge in the San Francisco Bay Area on a foggy night.

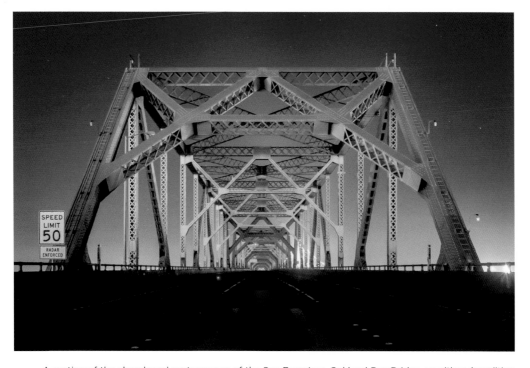

A section of the abandoned eastern span of the San Francisco-Oakland Bay Bridge, awaiting demolition after its replacement by a newer span.

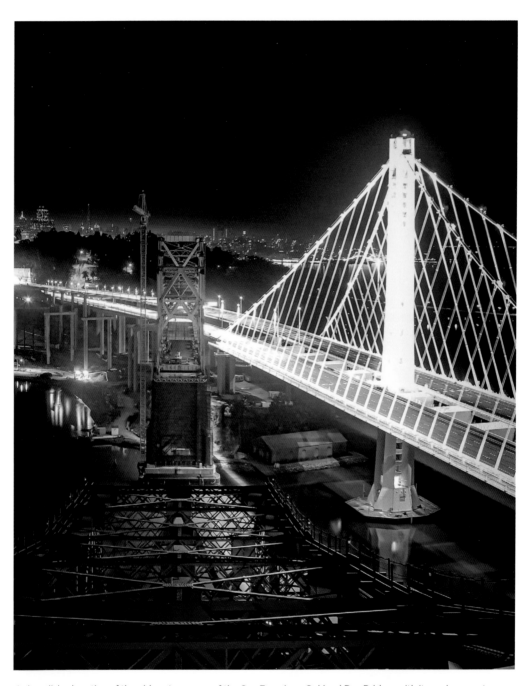

A demolished section of the old eastern span of the San Francisco-Oakland Bay Bridge, with its replacement span bypassing it.

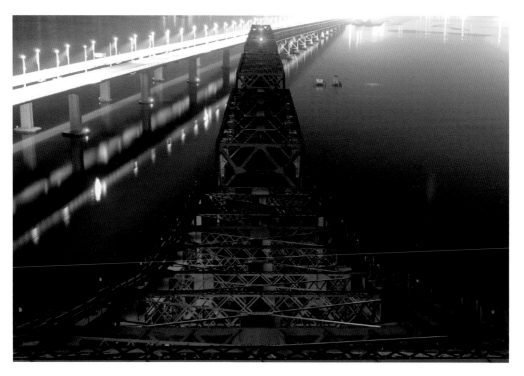

Looking down the old eastern span of the San Francisco Bay Bridge, and the new replacement span on the top left.

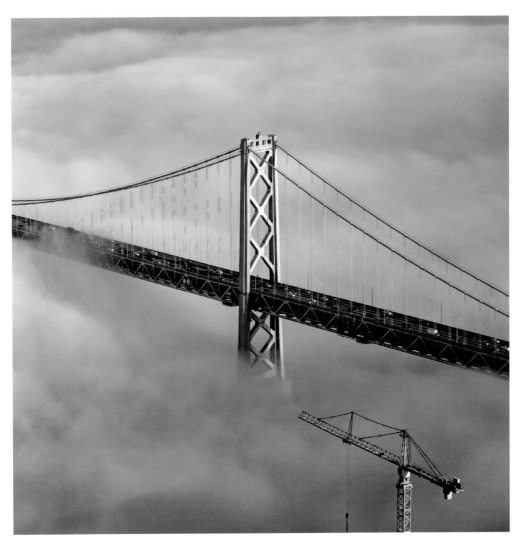

The San Francisco-Oakland Bay Bridge seemingly floating above the fog.

3

The Future of the Bay Area

San Francisco has experienced many rapid transformations over the past two centuries, each one of them bringing an uneasy mix of excitement and uncertainties among its residents. From the Gold Rush to the dot-com bubble, and the most recent tech boom of the last two decades, the city has been defined by its ability to reinvent itself. It has both been a predictor of what the rest of America could become, but has also consistently evaded all predictions on its own future. Through the eyes of urban explorers, showing the juxtaposition of growth and decay, we can witness San Francisco's multifaceted transformations, ponder on what is being given to us or lost, and make our own guesses on what will become of this city.

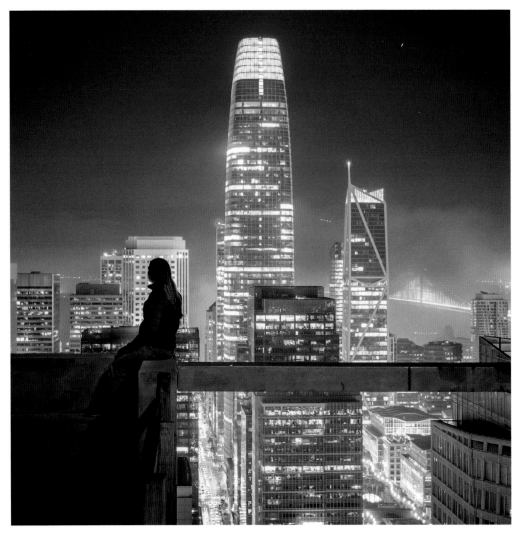

Seeking high vantage points to watch New Year's Eve's fireworks in downtown San Francisco.

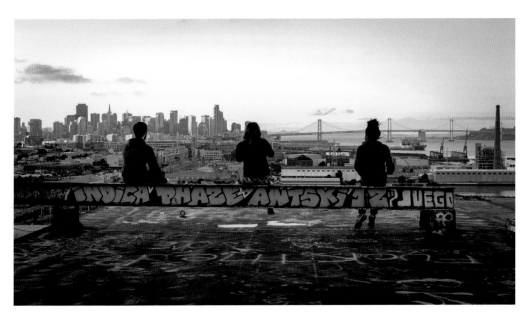

Sunset view of the San Francisco skyline.

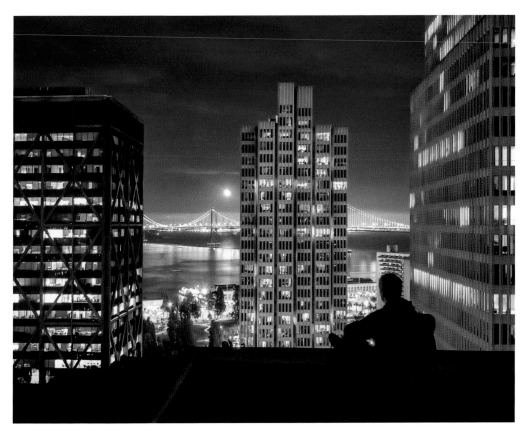

Rooftop view with the rising moon over the Bay Bridge.

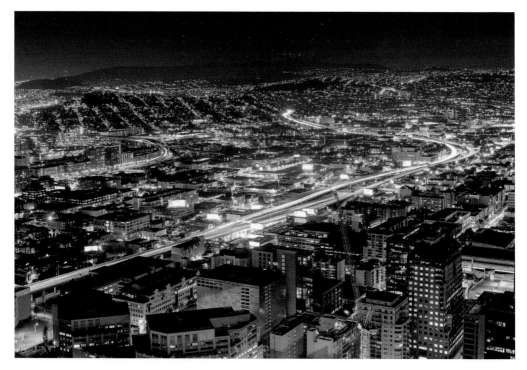

One of the main freeways connecting the Bay Bridge, Downtown San Francisco, and the Peninsula region.

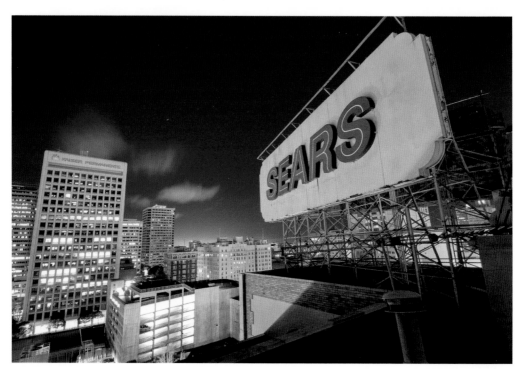

Abandoned multi-story department store in downtown Oakland, awaiting renovation to be turned into offices.

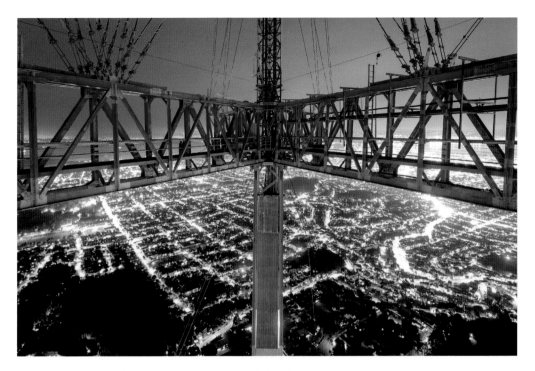

Observation level of a telecommunications tower in San Francisco.

Transportation Projects

When I first moved to San Francisco, I was surprised by the differences in public transit infrastructure between the Bay Area and my native Paris region. The kind of regional transit system that I took for granted in France, reaching through all parts of the suburbs without the need to drive, felt oddly inadequate in the San Francisco region. The Bay Area Rapid Transit (BART) system is the closest thing you can find to a region-wide transit system, but it still skipped over some of the most populous areas, most notably Silicon Valley and the entire city of San José.

This difference between Californian and French transit systems puzzled me for a while. But the more I lived in the San Francisco region, the more I understood the complex history and dynamics in American culture that led to the current situation. Many young Bay Area residents today see public transit as an essential piece of urban infrastructure, but to some suburban residents a few decades ago who had a say on the BART project, it was instead evoking fears of high public spending and loss of social, cultural, and racial boundaries. Add to that the importance of the car as a symbol of successful American life, these factors begin to illustrate why highways were favored over trains in many parts of the Bay Area.

For the past twenty years, public officials have tried to reverse this trend by expanding public transit construction projects, acknowledging the current limits of car-centric transportation, mainly high commute times and air pollution. In downtown San Francisco,

the Central Subway, a new underground metro line, has been in the works since 2012 and is set to open by 2021. Not too far away, the opening of the 1,400-foot-long Salesforce Transit Center in 2018, and its re-opening in 2019 following last-minute structural retrofits, shows how public transit is coming back to the forefront of transportation priorities, as well as the difficulties in completing this transition.

One of the public transit projects best illustrating this cultural shift is the planned rehabilitation of the Dumbarton Rail Bridge. Originally built in 1910 between Menlo Park and Fremont, it was the first bridge ever built across the San Francisco Bay, in a pre-car-owning era when trains were more ubiquitous. This rail bridge remained active until 1982, and was then left abandoned and structurally damaged by fires. But years later, with the bridge's convenient location close to the Facebook headquarters and other Silicon Valley urban centers, there has been renewed interest in renovating this rail line, to make it an important transit corridor across the South Bay Area. However, given the extent of the structural damage after decades of abandonment, the project's roadmap and timeline are still unclear.

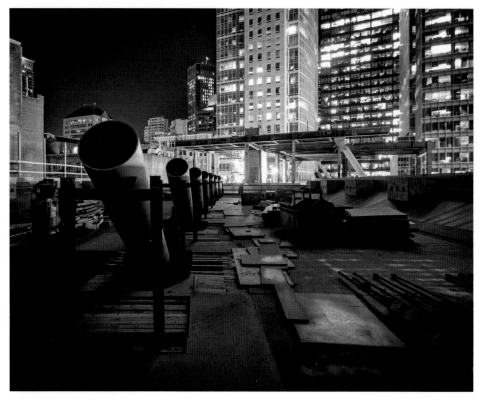

An urban overpass under construction to connect the Salesforce Transit Center to the freeway, allowing buses to get on an off easily.

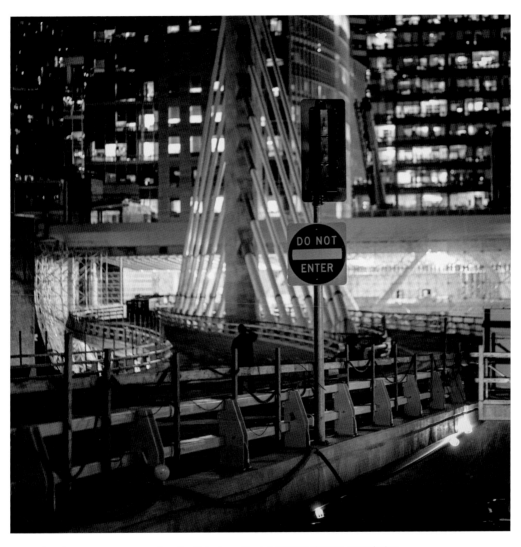

An urban overpass connecting the Salesforce Transit Center, close to completion.

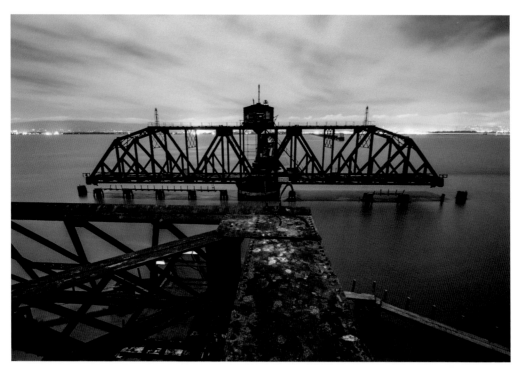

A disused swing bridge over the San Francisco Bay, now locked in open position to allow for maritime traffic.

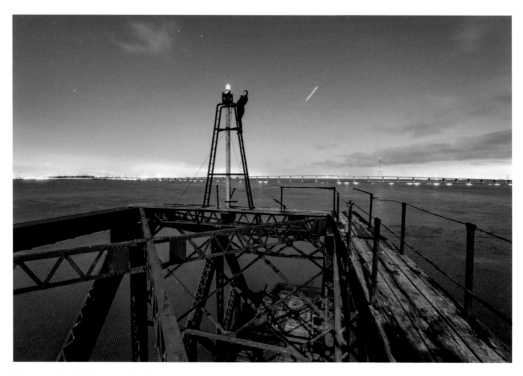

Atop a swing bridge over the San Francisco Bay.

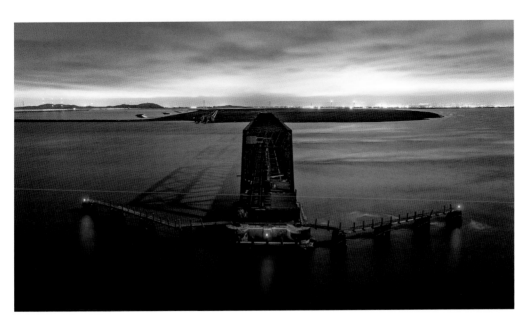

Looking towards the East Bay from a swing bridge.

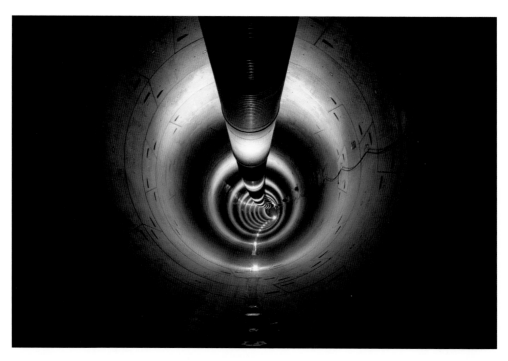

The Central Subway under construction in San Francisco.

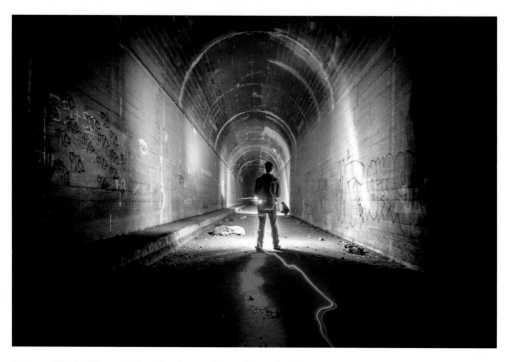

A disused light rail tunnel in San Francisco, going underneath a former military site.

On the next page: A future subway station under construction in San Francisco.

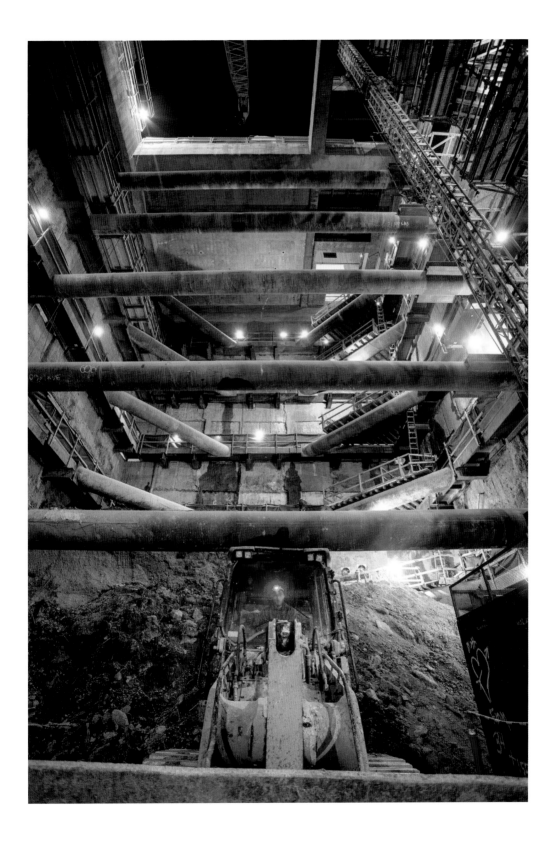

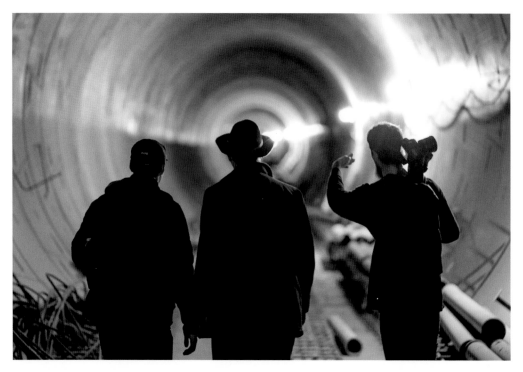

Three explorers looking down the length of the Central Subway under construction.

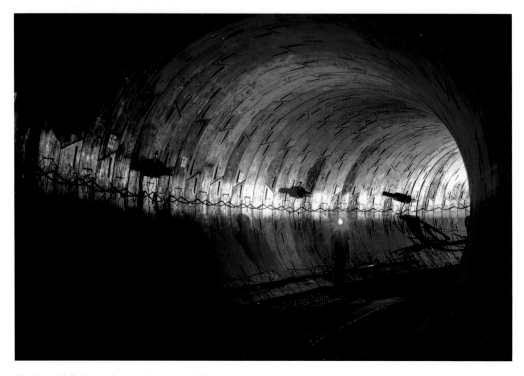

Playing with lights and colors in a curve of the Central Subway.

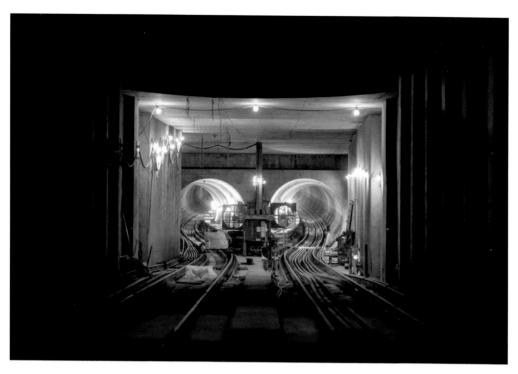

The Central Subway portal, connecting street-level light-rail tracks to the new underground section.

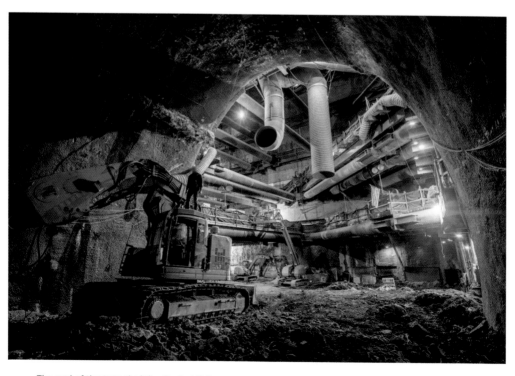

The end of the tunnel of the Central Subway.

Housing and High-Rise Constructions

San Francisco's worldwide attractiveness, spearheaded by the technology sector, its natural geographical constraints, and its lack of efficient region-wide transit system discussed earlier, have quickly turned the region into one of the most expensive housing markets in the world. This relatively sudden change in the housing market brought in new incentives for building developers to create more housing units in central urban locations, as well as offices closer to city centers, as opposed to sprawling tech campuses far out in the suburban Silicon Valley. One of the most recognizable monuments of this new construction boom is the Salesforce Tower, setting new height records for San Francisco buildings at 1,070 feet when it opened in 2018. Still causing debate among residents who either love or hate its presence in the city and often disagree on its symbolism, it undeniably reinvented the San Francisco skyline previously dominated by the Transamerica Pyramid skyscraper. Among new housing units, many of them are high-rise and high-end condos, catering to the quickly growing upper class of Bay Area residents. One of them, the Four Seasons Private Residences on Mission Street, was designed to have San Francisco's most expensive penthouse, with an asking price of $49 million, after its completion in late 2020. But because the most recent series of technology companies' IPOs in 2019 underperformed what analysts originally expected, and because of the economic uncertainties linked to the COVID-19 pandemic, one could question whether the age of high-rise luxury condos in the Bay Area is coming to an end.

At the same time, affordable housing remains a high priority in the region, with more and more households not being able to keep up with soaring rent prices. Despite a general consensus among Californians that something should be done to solve this housing crisis, little progress has been achieved over the years on that question, in San Francisco and the rest of California alike. Different classes of residents have vastly different and contradictory ideas on how to solve this crisis, entrenched by competing economic interests of new renters versus existing homeowners, which explains why progress has been so slow on that question. But the sudden economic changes of 2020 could break this stalemate on affordable housing and change the political equation in the near future.

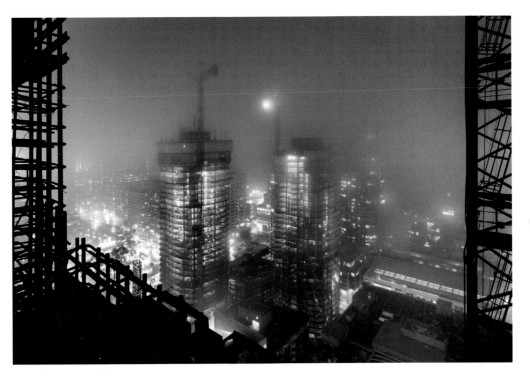

New residential high-rise construction in downtown San Francisco.

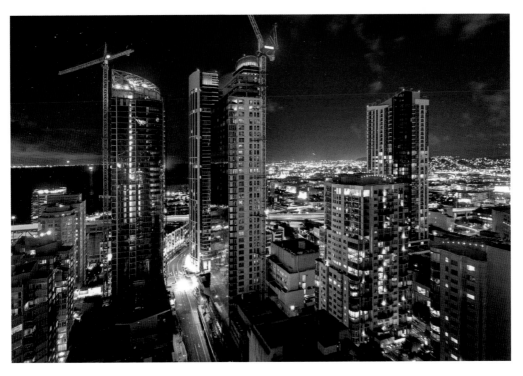

Luxury apartments under construction at the foot of the San Francisco-Oakland Bay Bridge.

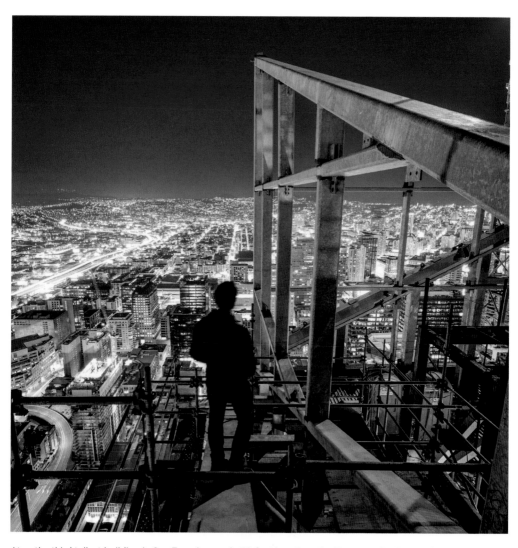

Atop the third tallest building in San Francisco, only 50 feet less than the Transamerica Pyramid.

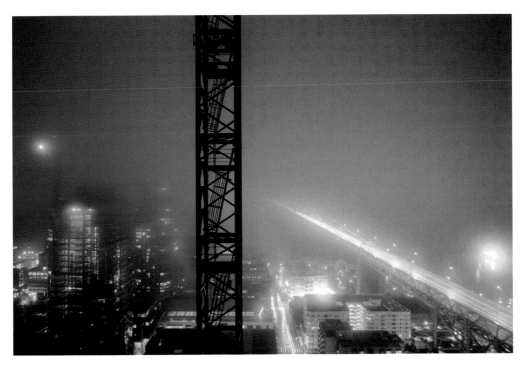

The San Francisco-Oakland Bay Bridge disappearing into the late-night fog, with a construction crane in the foreground.

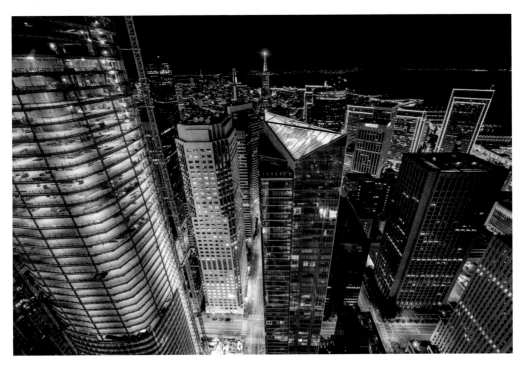

The soon-to-be-finished Salesforce Tower (left), sitting next to the Millennium Tower (center).

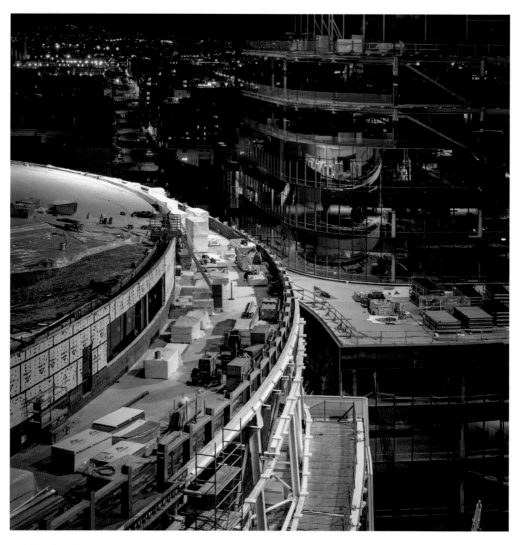

Building the Chase Center, the new sports complex south of San Francisco, before its opening in 2019.

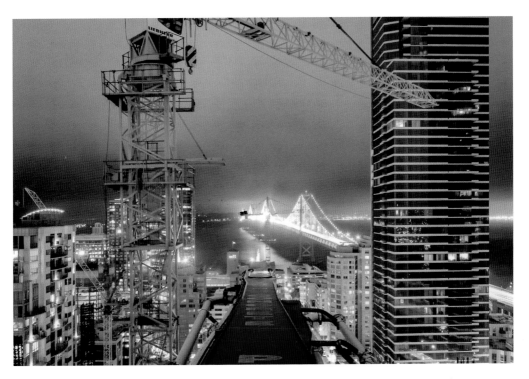

View from San Francisco in the early days of the recent SOMA and Downtown construction boom.

On the next page: Stacked floors of the Salesforce Tower under construction.

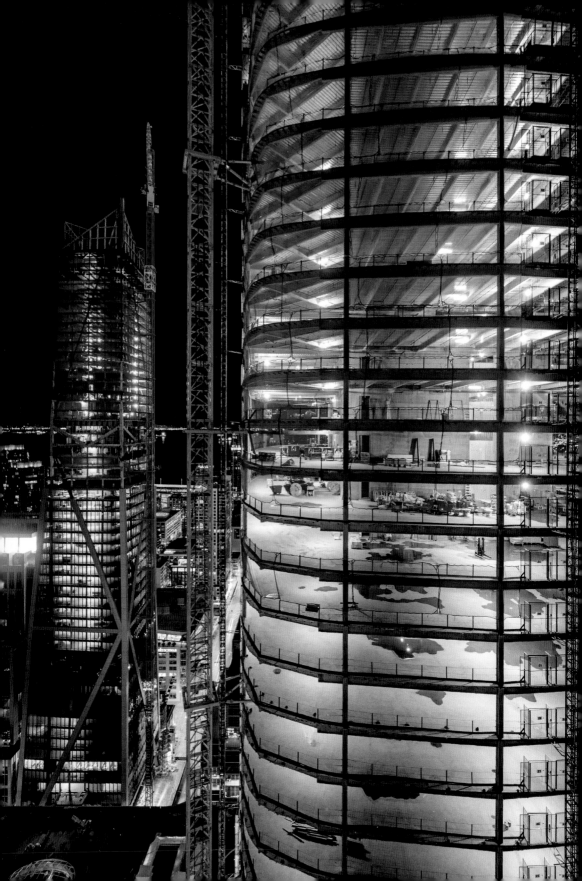

Culture and Spirituality

Aside from its economic impact on the world, the San Francisco Bay Area also made its mark on global culture as a center for many creative and spiritual movements. While some of these movements still inspire generations today, like the hippie and psychedelic movements in the 60s and 70s, one of their most unexpected legacies is how they changed San Franciscans's relationship with religions. As of 2020, the San Francisco Bay Area is one of the least religious regions in America, and the few residents that do practice religion are not in majority Christian. In a country where, up until a few years ago, the majority of Americans said they were unwilling to give their vote to an atheist for President, this too sets apart the region from the rest of the U.S.

This situation leaves us with several churches of various denominations, spread around different cities in the Bay Area, being left abandoned, only to be demolished or converted into non-religious event spaces, preserving parts of their historical and architectural legacy. But behind the formerly recognizable churches of major organized religions, the 60s and 70s started their own spiritual movements in San Francisco. Many followers of such movements, wanting to experiment with new ways of living and organizing societies, retreated in sparsely populated areas outside of San Francisco to establish living communes. For the dedicated urban explorer, some of these communes can reveal themselves hidden in the woods, sometimes beautifully preserved, showing the past dreams and ideas of these residents wanting to invent something different from mainstream society.

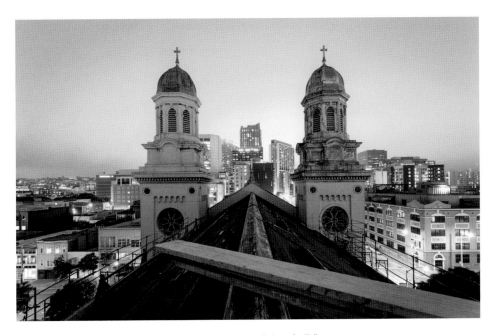

A former church, under renovation to become a non-religious building.

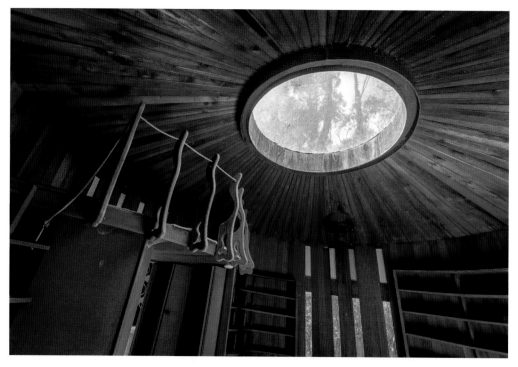

The library room of a hippie commune hidden away in the woods of the Bay Area.

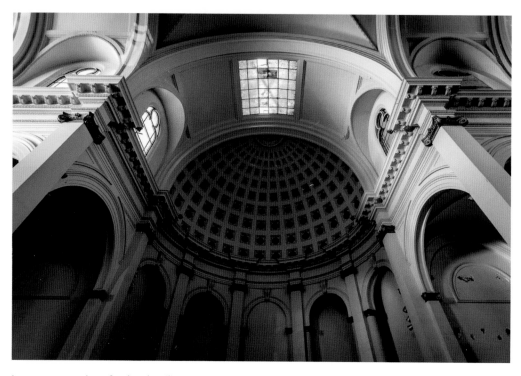

Long-exposure view of a church ceiling in San Francisco.

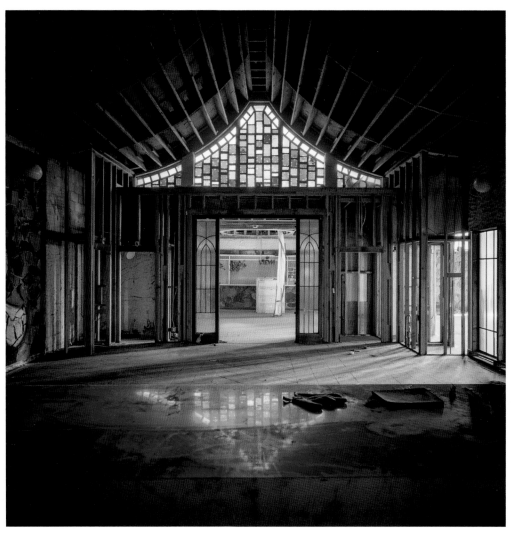

An abandoned church in San José, awaiting demolition.

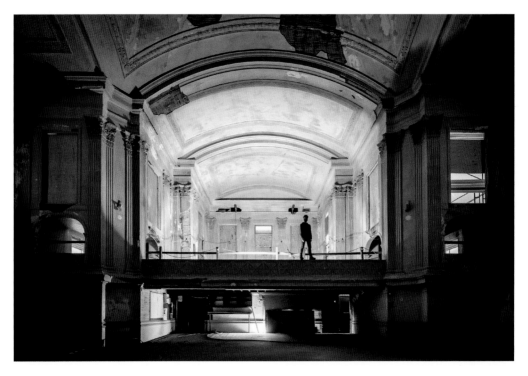

The First Church of Christ Scientist in San José, built in 1905, soon to become part of a residential complex.

The library room and balcony of an old hippie commune.

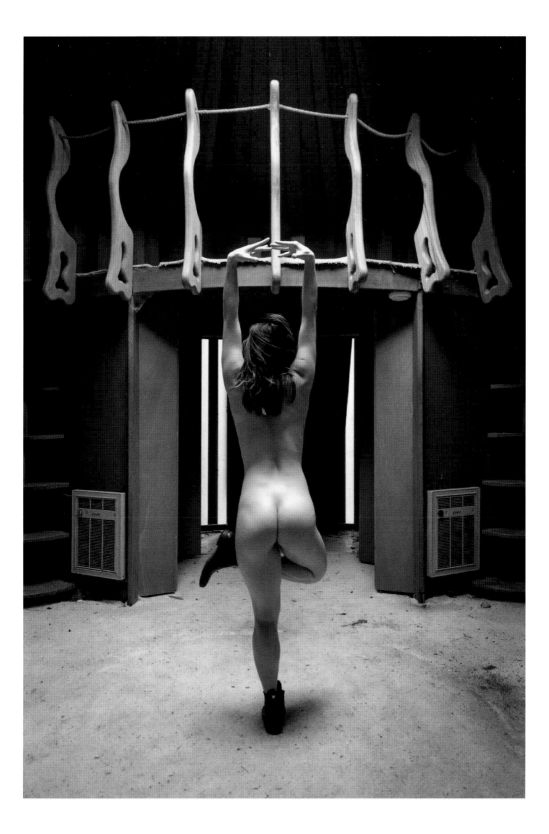

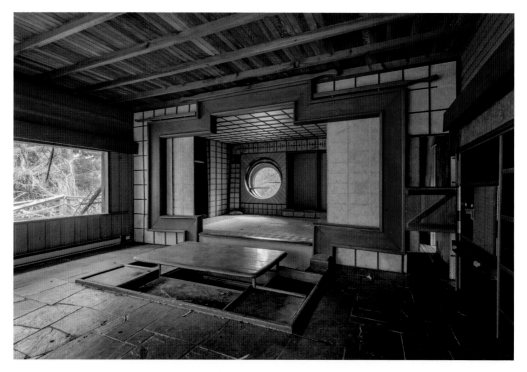

Well-preserved Japanese-inspired communal room in an abandoned hippie commune.

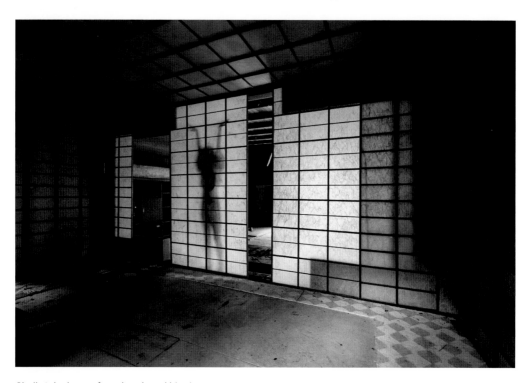

Shoji-style doors of an abandoned hippie commune.

It is not rare to hear people claim that the hippie movement and its contemporaneous utopian thoughts did not create anything substantial, because the majority of these self-organized communes did not achieve any kind of long-term sustainability. However, there is an interesting parallel to be made between San Francisco communes of the past, and technology start-ups of the modern era: the vast majority of them fail, but the ones that succeed end up becoming influential to the point of changing the status quo. The same critics dismissing the impact of these hippie communes might not be aware that living communes are seeing a renaissance across the U.S. in the form of intentional communities. Today, it is estimated that about 100,000 people live in such communes all across the country. This might not have happened on such a scale without the influence of these spiritual and cultural movements born out of San Francisco. And within the Bay Area, some lingering legacies of the hippie movement are starting to resurface today, with two Bay Area cities pioneering the decriminalization of psychedelic mushrooms in the last two years, after decades of near-complete suppression in the entire country. Looking back at the impact of the last fifty years of San Francisco culture, there is no doubt that the region will keep on spreading its multifaceted influence onto the world in thought-provoking and unexpected ways.

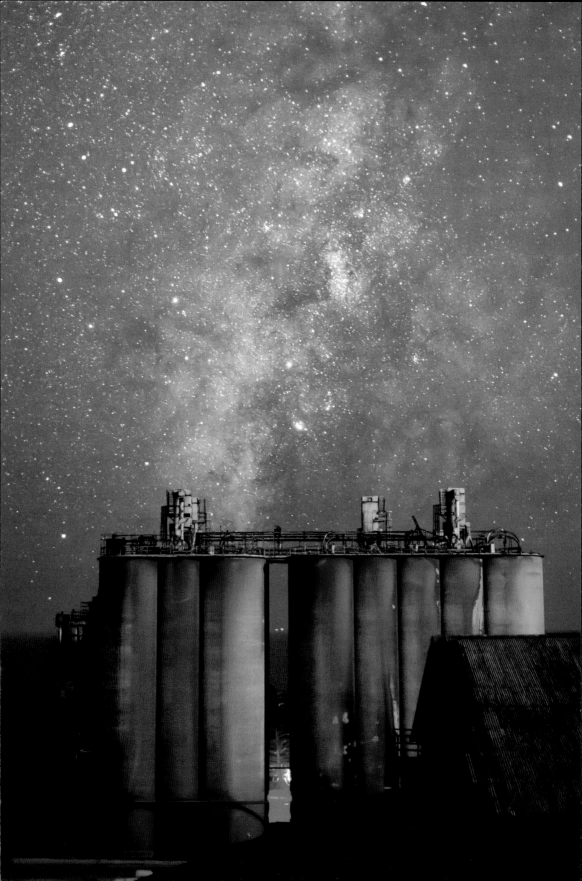

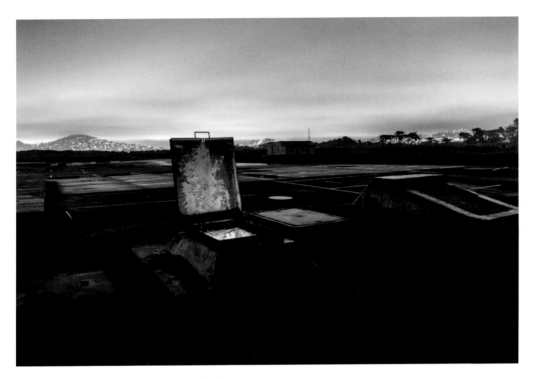

A mysterious hatch on a parking lot in San Francisco.

An abandoned cement plant in a coastal area of the Bay Area with low light pollution, letting the Milky Way peak through.

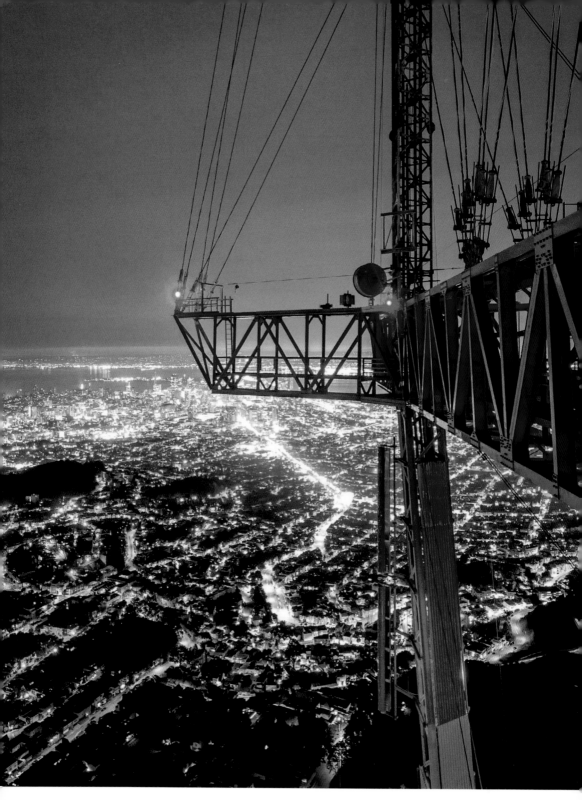

Admiring the view over Downtown San Francisco from a telecommunications tower.